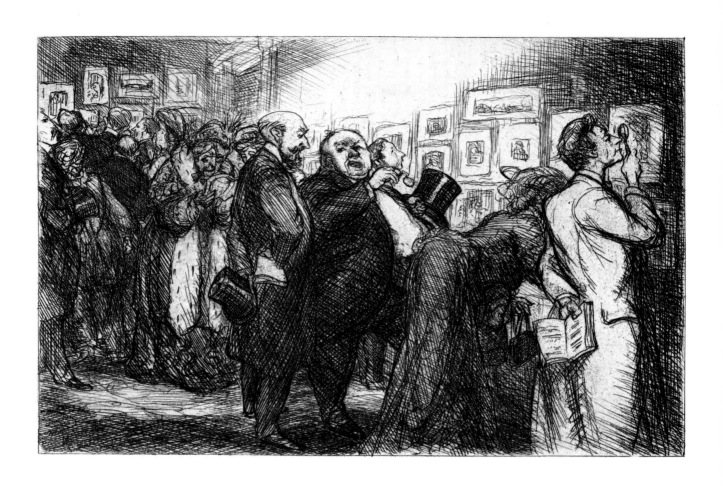

JOHN SLOAN

New York Etchings

(1905-1949)

edited by
Helen Farr Sloan

Dover Publications, Inc.
New York

Frontispiece: CONNOISSEURS OF PRINTS 1905
4½ x 6¾ M-127

"The first of my New York life plates. It shows an exhibition of prints that were to be auctioned at the old American Art Galleries on 23rd Street. The first of a series of 'Connoisseurs' planned, but never made. . . . Henri was so pleased with this one. He offered to assist me financially so I could spend all my time with these city-life etchings. I think I accepted a loan of two hundred dollars, maybe it was five hundred. But it made me nervous to be in debt so I continued to look for free-lance magazine illustration to pay for the rent and food. I like to feel independent." [The original set of ten *New York City Life* etchings are represented here by the frontispiece and Nos. 2–10.]

Published in Canada by General Publishing Company, Ltd., 30 Lesmill Road, Don Mills, Toronto, Ontario.
Published in the United Kingdom by Constable and Company, Ltd., 10 Orange Street, London WC2H 7EG.

New York Etchings (1905–1949) is a new work, first published by Dover Publications, Inc., in 1978.

International Standard Book Number: 0-486-23651-X
Library of Congress Catalog Card Number: 77-94929

Manufactured in the United States of America
Dover Publications, Inc.
180 Varick Street
New York, N.Y. 10014

INTRODUCTION

by Helen Farr Sloan

JOHN SLOAN is probably most familiar to the reader as a member of "The Eight," that group of American artists who put on an exhibition at the Macbeth Gallery in 1908 in protest against the National Academy jury's rejection of work by George Luks and even Robert Henri. Some may associate him with the Independent Artists, who put on a large show in 1910 which was the precursor of the famous 1913 Armory Show. The Independent Artists movement, a progressive phase of the avant-garde, working for "open door" exhibitions organized on a voluntary basis by the artists themselves, led to the Society of Independent Artists, of which Sloan was president from 1918 until its end in 1945.

The most familiar of his paintings seen in textbooks are *The Wake of the Ferry* (1907), *McSorley's Bar* (1912) and *Backyards, Greenwich Village* (1914). A few of Sloan's New York City life etchings are well known, but this is the first time that the whole range of these prints has been reproduced in book form for a very modest price. How much this would have pleased the artist, who made these pictures for his own pleasure— and with the idea that they could be available to consumers of art for very moderate prices! In this informal introduction I will report some of the history of these prints, as Sloan told it to me and discussed it with interviewers, and as he recorded the events in his diary. Here and there I will add a note from the later perspective of 1977.

A word of explanation is due about the comments that are printed along with the plates. In 1944, shortly after John Sloan and I were married, Sam Golden, whose American Artists Group had published Sloan's teaching book *Gist of Art* in 1939 (reprinted by Dover, 1977), asked Sloan to plan a small book of his etchings with comments. This publication never came to fruition because of wartime production problems, but soon after we had started working on the selection and comments Sloan was invited to have a retrospective exhibition of all his etchings at the University of Chicago. This was to be held concurrently with his visit to the University to give the Moody Lecture in February 1945. The comments prepared in 1944 were used as labels at that exhibition. In 1946, at the suggestion of Sloan's cousin John Sloan Dickey, President of Dartmouth, that college held a seventy-fifth anniversary retrospective exhibition of

Sloan's work. Many of the comments were printed in that catalogue as well. They later appeared in the text of Peter Morse's catalogue raisonné, *John Sloan's Prints* (published by Yale University Press, 1969), which also included relevant excerpts from Sloan's early diary (published by Harper & Row in 1965 under the title *John Sloan's New York Scene . . . 1906–1913*). In the captions for the present book, I have used the 1944 comments, quotations from the early and late diaries, and some unpublished notes. While reading Sloan's 1944 comments, please bear in mind that he was looking back as much as thirty-nine years, and that more than thirty additional years have passed since then.

When Sloan moved to New York City from Philadelphia in 1904, he found a studio apartment at 165 West 23rd Street in the Chelsea district. This building, still occupied in 1977, was a made-over private dwelling five stories high. Sloan and his wife Dolly lived on the top floor in what had undoubtedly been the servants' quarters. He said it was unbearably hot in summer. They had gas lighting and coal stoves, and an icebox in the hall. The rent was expensive at $50.00 a month when his only regular income was $15.00 a week from "word-charade puzzle" drawings made for the Philadelphia *Press*. He was thirty-two years old, and had been working full time since leaving school at the age of sixteen to become the main support of his parents and two young sisters. "I might have been a doctor, lawyer or preacher. But I sort of drifted into art as a way of earning a living. My first job was as assistant cashier in the Philadelphia bookstore Porter and Coates, where they had a print department. I was allowed to borrow etchings by Rembrandt, which I copied in pen and ink. I could sell these copies for about $5.00. That was a welcome addition to my take-home pay of $6.00 per week. Then I taught myself to etch, using Hamerton's *Handbook*."

Sloan was born August 2, 1871, in the small lumbering town of Lock Haven, Pennsylvania. His father, James Dixon Sloan, came from a long line of Scotch cabinetmakers; they had been in America since the early eighteenth century. Displaced by modern factory methods, the elder Sloan might have been a creative inventor if he could have worked under a man like Edison. Sloan's mother, Henrietta Ireland, was Scotch-English, descended

from the same family as Joseph Priestley. Her sisters had been educated in Switzerland, but she had gone to a teachers' training academy and was teaching English in Lock Haven. The Priestleys and Irelands, who had come to Delaware early in the nineteenth century and had a flourishing paper business in Philadelphia, had intermarried with cousins in Ireland and England, so their Philadelphia household was an outpost of Victorian culture. Sloan's father moved his family to Philadelphia in 1876, in search of work.

From childhood Sloan was familiar with the work of Hogarth, Cruikshank, Rowlandson, Caldecott, Thackeray, Doré, Tenniel. His great-uncle Alexander Priestley had a fine library where the boy saw original prints and could pore over copies of *Punch* and *Harper's*. His mother's sister was married to the son of Marcus Ward, a Victorian publisher ("Illuminator to the Queen") who brought out books illustrated by Walter Crane (Crane's brother Thomas was their production designer). Sloan's father became a traveling salesman for the American branch of the business (which was run by his brother-in-law Alfred Ireland), selling books, greeting cards and fine stationery. So the future artist was brought up in a world of books, "reading all of Dickens and Shakespeare before I was twelve." He illustrated his own copy of *Treasure Island*, and copied all the illustrations in the family dictionary. "My sisters and I drew equally well as children. We had books and tools and materials to work with. I never realized that we were poor. We were poor, but not underprivileged."

From the time he had to leave school, Sloan was really self-educated. Finding that he could get an extra fifty cents now and then for a hand-drawn greeting card with his humorous verses, after two years in the bookstore he took some night courses in freehand drawing. Meanwhile, A. Edward Newton, one of the clerks, started his own "notions business" and asked Sloan to work for him as a designer of novelties and calendars. For Newton, who later became well known as a bibliophile, Sloan made about fifty etchings. Some were original concepts; others were based on photographs of such subjects as Westminster Abbey and the homes of the poets. This series of agreeably designed and technically competent etchings provided solid experience with the medium. The printing was done by Peters Bros. in Philadelphia, professional printers for many well-known etchers of the period. From them Sloan gained much practical knowledge that could never be acquired from books. There were no classes in printing in the art schools. After two years with Newton, Sloan tried to earn his living as a free-lance artist; but in competition with the new advertising agencies he was no better as a salesman than his father had been.

With a portfolio of samples, including some in poster style based on his study of Walter Crane, Sloan found an appreciative editor at the Philadelphia *Inquirer*. He was offered full-time work in the art department, where he was allowed to concentrate on illustrations for the entertainment pages and for the serialized stories in the Sunday supplement. Unlike his friends Everett Shinn, George Luks and William Glackens, Sloan did very little work as a reporter-artist. His poster style, developed before he had seen any work by Beardsley, gained national recognition through the *Inland Printer* and Chicago *Chapbook*. He worked as editor of some little poster-period magazines and collected a few Japanese prints. It is interesting to see the old prices on the backs of his prints by Hokusai and Hiroshige: $1.25 seems very little, but it was a kind of luxury for someone earning less than $25.00 a week and supporting five people. The Japanese prints were important to him for study of abstract design, for the subject matter of everyday life, and for the idea of making prints that could be sold at moderate prices.

Sloan worked on the Philadelphia newspapers for more than ten years. His pen-and-ink illustrations in decorative Art Nouveau style made striking designs on the printed page. Later on, he made some full-page "puzzle" drawings in color, also in Art Nouveau style but without the bizarre character that the style often manifested. Sloan was also making illustrations in the traditional pen-and-ink technique practiced by Leech, Keene, du Maurier and others. He was familiar with the work of Dürer, which exerted such great influence on Pyle, and he appreciated such contemporary draftsmen as Abbey, Frost and Keppler. He became excited over his discovery of Daumier, Goya and Steinlen, whose work he now saw in abundance, and not merely in a few examples. These were the draftsmen-printmakers—along with his greatest admiration, Rembrandt—whose work was of most importance in Sloan's preparation as an etcher.

Meanwhile, with the encouragement of his friend Robert Henri, Sloan had started to paint portraits and memory-scenes of Philadelphia, working in a muted palette related to Manet's. The first painting he sent to a jury was *Independence Square*, accepted by the Carnegie Institute in 1900. But he had only a few hours of daylight free in the morning for independent work, and was still the main support of his family. In 1901 his sisters were old enough to assist with this responsibility and he was finally free to marry. His wife, a tiny little Irishwoman, called by their friends "Sloan's outboard motor," was a tender, hardworking helpmate who never pressed him for financial success. Nor did she try to influence his creative moods. Her only faults were a problem with depression and a chronic battle with alcohol. They took care of each other for forty-two years.

Shortly after John and Dolly were married, he was offered the project of illustrating a series of novels by Paul de Kock. These were considered rather racy pictures of French life in the early nineteenth century, second-

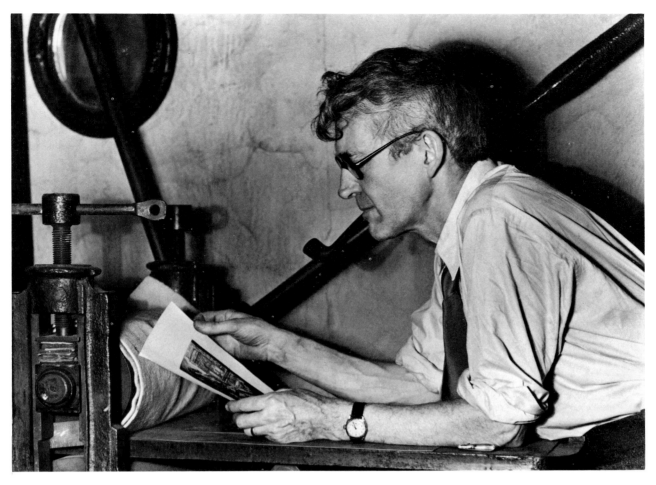

John Sloan at his etching press in 1933.

rate compared with Balzac but full of the human comedy. This commission, carried out between 1902 and 1905, involved making over fifty etchings and a similar number of drawings. Limited editions of such illustrated books were much in fashion at the time. Sloan had a wonderful time doing research on French life, studying books of costume, furnishings and the like. "I had maps of Paris and got to know the place so well in imagination that I could have found my way around its streets in the dark. A French critic who saw my work could not believe that I was not a native, to say nothing of the fact that I had never been abroad." Perhaps one reason that such fine illustrations were made by Sloan and Glackens for these sentimental and slightly salacious texts is precisely because the writing was so lightweight that the artists were free to produce vigorous, imaginative drawings.

To undertake this extra work Sloan cut down his Philadelphia *Press* schedule from six to three days a week. His newspaper-artist friends Luks, Shinn and Glackens had moved to New York around 1896; the editorial offices for most of the magazine and book publishers were there. Free-lance illustration had become the main source of income for these artists.

Just as Sloan was nicely organized, with time for some painting, a steady income from newspaper work and this commissioned job for the de Kock novels, automation caught up with his work on the *Press.* The newspaper decided to subscribe to a syndicated Sunday supplement. So Sloan had to follow his friends to New York, seeking work from the editors of *The Century, Scribner's, Mc-Clure's* and other magazines. In 1904 the progressive movement was uncovering all kinds of injustices in city life and industrial organization. It was the great day of the "muckraking" writer. Sloan found interesting assignments from time to time, but the editors pigeonholed him so often as an "Irish humor illustrator" that he was not in great demand. Artists like Pyle, Gibson and Remington appealed more to popular tastes.

"As I walked the streets with my portfolio of samples,

going from one publisher to another, I saw the life of the city really for the first time. All those years on the newspapers, I had worked most of the day and evening. I had neither time nor reason to see the neighborhood life of the city. Coming to New York and finding a place to live where I could observe the backyards and rooftops behind our attic studio—it was a new and exciting experience. Work on the de Kock illustrations, although of a completely different place and period, had fired my creative imagination and increased the technical skill in handling the etching needle. . . . New York had its human comedy and I felt like making pictures of this everyday world. At first I had some idea of social commentary based on Hogarth's morality series or Daumier's dramatis personae. But I found that this was not the kind of motivation which was most valid for my own personality and talent. . . . I saw neighborhoods of the city, and saw the kind of people who lived, worked and played in the Chelsea district, the Tenderloin around Sixth Avenue, then Fifth Avenue, the parks, etc. On the whole, when finding incidents that provided ideas for paintings, I was selecting bits of joy in human life. I did not have any didactic purpose, I was not interested in being socially conscious about the life of the people. In my etchings, there was sometimes a more satirical element."

The etchings here referred to were those done in 1905 and the years immediately following. Ten of these (later increased to thirteen) comprised a set known as *New York City Life*. In the present volume, the frontispiece and Nos. 2 through 10 are the original ten, dating from 1905 and 1906; Nos. 15–17 are the later additions. Sloan would not allow the prints in the set of ten to be sold separately until late in 1908.

These early years in New York are not only visualized in Sloan's paintings and prints; they are also reported in the diary he kept in a style similar to that of Pepys, one of his favorite authors. In a day-by-day account Sloan tells about making his first New York City life etchings, his efforts to sell them, his surprise that some were considered too shocking to remain in an exhibition in which they had been included. "I know that my work is not 'vulgar' or 'indecent'!" Although these prints were admired by artists like Robert Henri, Arthur B. Davies and J. Alden Weir, appreciation for them in the form of sales was almost nonexistent. In both the diary and Sloan's financial records for 1905–1910 there is stark evidence of contemporary neglect.

In 1906, one set of ten etchings was sold for $24.00, less one third commission. Total income from etchings that year: $81.25. The next year, "The Eight" was being organized, so there was a good deal of newspaper publicity for artists of the Fourth Estate, and Sloan's income from prints was $115.00. Because of a business recession the financial return from Sloan's independent printmaking shrank to $39.00 in 1908. In 1909 the returns

were even lower; only one set of ten prints was sold for $18.75. If Sloan's motivation for doing his own creative work had depended on contemporary sales or critical appreciation, he would have stopped producing. Fortunately he had friends like Robert Henri who took the long-range view that if you work to please yourself you have no right or reason to be bitter when the work has no immediate recognition.

The first collector who took an interest in Sloan's etchings was the lawyer John Quinn. He acquired a fine collection of special proofs from Sloan in 1910, for $340.00. In 1912 Sloan tried to reach an audience interested in social and cultural affairs; he placed an ad in the program for a "Concert and Ball" being held at the Rand School of Social Science. The offer of one signed proof for $5.00, three for $10.00, or ten for $25.00, had no takers. A year later, when he was art editor of *The Masses*, a liberal magazine using work by Art Young, Boardman Robinson, George Bellows and Stuart Davis, he placed an ad offering any city-life print for $2.00 along with a year's subscription. There was no response. Finally, in 1915, he tried sending an illustrated brochure to fifteen hundred people listed in *Who's Who*. Two sets of prints were purchased, one by the illustrator C. J. Taylor, the other by John Cotton Dana for the Newark Public Library.

Sloan's desire to make prints to sell for moderate prices to an audience that had apparently enjoyed his illustrations in newspapers, magazines and books, had obviously come up against prejudices and fashions in taste. Seymour Haden, Whistler, Pennell and Zorn were the proper printmakers to be collected by connoisseurs who respected Dürer and Rembrandt—but who would have found Daumier too realistic. I sometimes wonder whether the progressive intellectuals of that era accepted the muckraking writers more easily because the words were at one remove from reality. In fact, they may have accepted the great realistic photographs of urban poverty made by Jacob Riis more easily than graphic statements by men like Glackens and Sloan and Jerome Myers. For many years the "fine art" made by the early New York Realists was called "black illustration"; it was condemned as ugly realism. On the other hand, a later school of criticism spoke with scorn of its romantic feeling, whereas yet another revision in terminology pigeonholed the work as nostalgic. It is only in recent years that exhibitions and publications have shown the pictures for themselves, to be judged by the visual image instead of the verbal labels.

After 1913, the year of the Armory Show, Sloan stopped keeping a diary, resuming only in the 1940s. The background of his later life and attitude toward art has largely been filled out from archives and interviews. (It was also in 1913, at the age of forty-two, that he sold his first painting, to Dr. Albert Barnes, who also bought a number of etchings.) He taught some private pupils

drawing, painting and sometimes etching. Illustration was providing less of his income. Albert Gallatin took an interest in his work and published a little monograph on the prints of Sloan and Arthur B. Davies. By now Sloan had decided that there would be no use in trying to sell his etched work at so-called popular prices. He had established an edition of one hundred for each plate (although very few plates had been printed up by the time he died in 1951), and formed the policy of starting the price very low, with the selling price to increase as the edition sold. In 1916, I doubt very much whether he had realized enough from selling prints to pay Peters Bros. in Philadelphia for the cost of printing the proofs which he had in stock.

The year 1916, when Sloan was forty-five years old, was an important turning point in his professional career. He was invited to have his first one-man shows, at Mrs. Harry Payne Whitney's Studio on Eighth Street and at the Hudson Guild Settlement House under the auspices of the People's Art Guild. Paintings, drawings and prints were exhibited and recorded in modest catalogues. Then Kraushaar Galleries started to handle his work. The association with this dealer has lasted more than sixty years. Sloan started to teach regularly at the Art Students League, from 1916 off and on until 1938. Sloan's students included such diverse talents as Reginald Marsh and Peggy Bacon, Alexander Calder and David Smith, John Graham, Adolf Gottlieb and Barnett Newman. "Teaching took more and more of my time and energy in the winter months. I was painting in Gloucester [Massachusetts] in summers from 1914 to 1918. Then in 1919 a trip to Santa Fe opened a new world of subject matter for me."

About New York, Sloan remarked: "Prohibition changed the city. The skyscrapers changed the human scale of streets and parks. Pollution dirtied the laundry and made the air unhealthy, especially in the summer heat. While I am all for labor-saving devices, I did miss the sight of women putting out laundry on the rooftops —the flower gardens of the city. The streets were full of automobiles, like giants' boots cluttering up the neighborhoods. . . . Some critics have complained that I did not stick to city-life subjects and others think I should have followed all the twists of modern fashion. I have earned the time to do my own work, to work as a humanist, a spectator of life around me. It can be a blessing to be ignored by the critics: you have privacy to do your own work."

There are over sixty pictures of the city etched on metal, seven lithographs of the city and over sixty paintings of the city. Humanism remained the keynote of Sloan's work, in genre, landscapes, figure and portrait subjects. He felt that he had *earned* the time to do his own work, in any style and on any subject he chose. "I don't think the artist is obliged to respond to speed and space, the age of science or the age of chaos. Young students are too much influenced by the tides of fashion in philosophy. How can you expect to develop your own talent, keep your own integrity, if you are swayed by the whims of commercial success in the art market? What respect can you have for yourself, your profession? Another thing—art talk and art criticism and art history can be taken too seriously in the wrong way. I like to say that I stayed in the profession because it is fun. I look upon myself as an amateur. An artist like Van Gogh or the later Rembrandt, men who worked for themselves. You don't really feel lonely yourself when you think about such great artists who were neglected by their contemporaries."

"The modern work we saw in the 1913 Armory Show was made by artists who had very little immediate success. When critics and collectors got on the bandwagon of 'modernism' too many followers picked up little formulas of abstraction. I wasn't interested in that kind of thing. But I learned from men like Duchamp and Picasso to have a new insight about the art of all times and cultures. I lost the blinkers of prejudice about subject matter, learned to appreciate the character of *significant form*, what Cézanne called *realization*. In my own work, whether painting in color or making prints in black and white, I tried to achieve greater plastic, graphic consciousness. The abstraction is cloaked in representational subject matter, but it is there. It always was there to some degree in my work because I worked from memory-concepts."

Sloan never used a camera to collect ideas for illustration, paintings or etchings. The illustrations were composed in imagination, perhaps in the way a novelist or playwright might work—supported by research but derived from observation of everyday humanity. The paintings and etchings, on the other hand, were composed around the immediate observation of city or country life. A specific incident became the catalyst for an idea combining emotional interest and an abstract design-problem. The idea sometimes lay fallow for months or even years.

Unlike such artists as Reginald Marsh or Maurice Prendergast, Sloan did not make a lot of sketchbook studies to use like pieces in a mosaic. He appreciated that way of creative thought for others, but it was not appropriate for himself. There had to be the nucleus of an idea found in direct observation, mulled over in imagination. The years of illustration work gave him a visual vocabulary, a set of graphic concepts for all kinds of things in nature, but he did not use these as stereotypes when composing a painting or etching.

As an artist-spectator of life, Sloan had always been handicapped by nearsightedness and astigmatism. He used field glasses to observe the rooftops, from the privacy of his studios. In the last thirty years of his life Sloan's eyesight was further handicapped by "double vision" caused by muscular weakness. It was most un-

fortunate that this was not corrected by surgery until 1945. For years he had worked under a strain, even when painting in the studio. It was very difficult for him to focus on the panorama of a city street with all the complexity of shapes and moving objects. He needed to use both eyes together to see with stereoscopic vision. The flat, visually photographic impression of reality seen with one eye was not enough for an artist who had always cared about the existence and vitality of real things. . . . It would be a mistake to regret that Sloan did not try to force himself to *concoct* pictures of the city in a creative technique that was against the grain of his talent.

In a 1947 interview conducted by Carl Zigrosser, Curator of the Print Department at the Philadelphia Museum, Sloan summed up some of his ideas about art and etching: "The line is the most powerful graphic symbol the artist has; it is the only purely invented device. You cannot see a line in nature, only the edges of tones. The use of line as a sign-making technique is what interests me in etching. I have nothing but contempt for the type of linework used to imitate brushstrokes in painting. . . . I don't have any special interest in the beauty of etching technique per se. As a craftsman I am patient but not finicky. I don't believe there is an etching 'connoisseur' in this country who has one of my plates. Probably they feel as many collectors do about modern paintings, that they 'could do it themselves just as well.' But I do have a profound concern for honesty of mental technique. I like linework that is talking about *things*. You can see that kind of straightforward line technique in the old engravings, the work of Dürer. Then there is a more descriptive 'talking' line and use of hatchwork that gives a feeling of light and shade enveloping and focussing on the forms. The greatest master of realization, Rembrandt, is for this reason the greatest etcher. He is great because of his mental technique, not for psychological insight or technical virtuosity."

At the time that Sloan was dictating his comments on the etchings to me, he also set down these hitherto unpublished technical notes in his 1945 calendar-diary:

"I draw on tissue paper, stretched out with Scotch tape. Just the linear plan, don't go far with tone. Use melted paraffin on the paper to make it transparent. Then I use a plumber's candle to smoke the waxed plate, while the plate is still hot. It should be an even polished black. If not even, the ground may be scorched. This can lead to foul-biting if the ground breaks down under the acid.

"Take the tissue, lay it face up (back down) on plate —with paraffin from candle.

"I reverse this 'tracing paper,' put on the plate, fastened with four bits of wax. Take another piece of tissue covered with red chalk, under the drawing [the chalked side facing the smoked surface of the plate]. Go over the lines of the drawing with a round-pointed tracing tool, thus transferring a red chalk drawing onto the plate.

"Now you have a black surface with red chalk drawing. Then you start to draw with etching needle. You get the glint of copper showing through the red chalk lines.

"Some etchers complete drawing a lot and use varnish-out method—lightest, most delicate lines. . . . Bit-biting by stopping out.

"My general method is a little different. My drawing on the plate contains the chief structural lines and more important textures. I give that a start, bite three or four minutes. Then lines that are to be more delicate [are drawn in]. Bite again. First batch has eight minutes; second, four. Go on in three or four stages. I wash off acid each time. Watch out for breaking down [of the ground]. Stop out where desired. . . . The linework does not bite evenly. There is more active biting of linework that is close together, hatching that has been bitten for the full eight minutes.

"*I bite from dark to light.* Start ½ and ½ water and nitric acid. Old acid, with copper, takes hold better.

"Clean off the ground. Hold the plate up against the light at an angle to study the depth of the lines. If I am satisfied with the work so far, or want to check on some problem areas, I take a proof. [He sometimes filled the lines with whiting to get a general impression of the linework, but preferred to pull a proof with ink to see the full effect of the black lines on white paper.]

"Retroussage can be used with care to strengthen and enrich linework. But it may be necessary to re-bite lines which need to be stronger. Skill and patience are needed for this job. The new ground must be very smooth. The needle must be handled with care if the lines are not to lose their fineness of touch. . . . Sometimes you can open up lines with the needle or graver.

"May bite one area 2″ square. . . . Biting with spittle, spreading the acid solution with a feather or camel's-hair brush. The acid comes to the edge like a lump. Areas without spittle refuse to 'take' the acid. . . . I rarely use the tray.

"I gauge the depth of lines with experience.

"I don't believe I ever got a first state that was satisfactory for final."

The following remarks about graphic art were made by Sloan at various times during the last twenty years of his life:

"A print is either a handmade thing, the personal work of the artist, or it should be put out in great quantity as a means of reproducing the artist's concept. Such prints should be sold at fifty cents or a dollar."

"I don't like to see these high-priced prints on the market. (Whistler and Zorn were in fashion when I started my New York life plates. . . . Nowadays, it is Picasso, Chagall, Miró, etc.) It deludes the public. They think the higher the price the better the work. It keeps them from having the courage to buy the work of unknown artists."

"And I don't like these fancy twenty-five-print editions

of etchings with each print numbered. It is just a scheme to make the public think the thing is precious, so they will buy. . . . It seems to me that an edition of one hundred is in good taste. The first prints should be sold at a modest price, and the price raised proportionately as the edition sells out."

"Any etching much bigger than ten by fourteen inches I consider to be in bad taste. The exceptions prove that rule. A few Rembrandts, Piranesi, etc. Prints by Dürer and Hogarth that are primarily engravings have a different kind of scale."

"Rembrandt had a sort of formula, way of thinking— which makes it possible for us to recognize his work. We see the difference between his work and that of his pupils or his contemporaries; recognize the difference almost intuitively. Style, in the work of the great artists, has no conspicuous earmarks."

"As for the American scene, you can't help seeing it. Artists like Winslow Homer saw it in the nineteenth century. It was not discovered by the Philadelphia realists who became the first so-called New York Realists. The art historians look at the calendar, and notice that our crowd were contemporaries of writers like Crane and Dreiser. So they assume that we were influenced by these American authors to see the American scene. But as a matter of fact we were brought up on Dickens and Shakespeare, Fielding and Sterne, de Maupassant and Balzac, Rabelais, Ibsen, etc. That was the kind of background we had for being artists in the tradition of Daumier, Manet, Hals and Rembrandt."

"I am a realist, working in the tradition of Daumier, Courbet, Rembrandt and Carpaccio. I am more interested in the noble commonplace of nature than in the curious: believing that form and color are tools of the artist's imagination in re-creating life" (John Sloan, quoted in Helen Farr Sloan's diary, June 22, 1950).

The Etchings

"In providing comments for the various pictures in this collection I shall endeavor to return to the mood under which they were produced" (from Sloan's introduction to the catalogue of the 1946 retrospective exhibition of his work at Dartmouth College).

In the following captions, unless Sloan's early and late diaries are specifically cited as the source, the comments in quotation marks are excerpts from the remarks prepared by Sloan in 1944 (see third paragraph of Introduction, above) and subsequently used as exhibition labels in Chicago, 1945, commentary in the Dartmouth catalogue, 1946, and background material in the Morse catalogue raisonné, 1969. The M-numbers given are those of that catalogue. The dimensions are in inches, height before width.

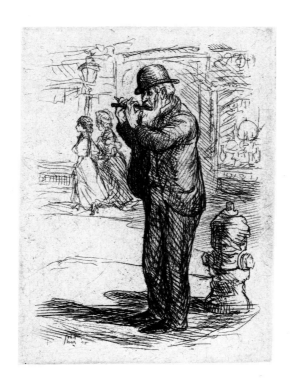

1 FLUTE PLAYER 1905 3¾ x 2¾ M-125

"This was made shortly after my arrival in New York. I am sure he was less awed by the great city than I was at the time."

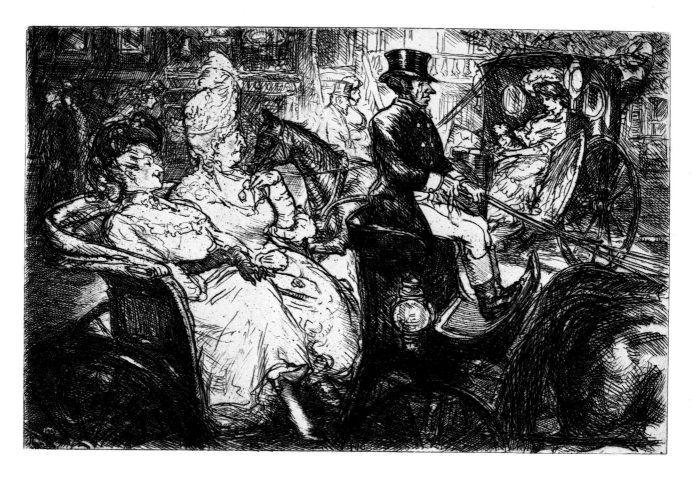

2 FIFTH AVENUE CRITICS 1905 4½ x 6¾ M-128

"These were typical of the fashionable ladies who used to drive up and down the
Avenue about four o'clock of an afternoon, showing themselves and criticizing
others. . . . I think the portraits are good; people have recognized them years later.
. . . Following the 'Connoisseur' idea, the proposed title of this plate had been
'Connoisseurs of Fifth Avenue' or 'Connoisseurs of Virtue.' But since the series
seemed to lapse after this time, it assumed its present title." [The frontispiece and
Nos. 2–10 constitute the original set of Sloan's *New York City Life* etchings.]

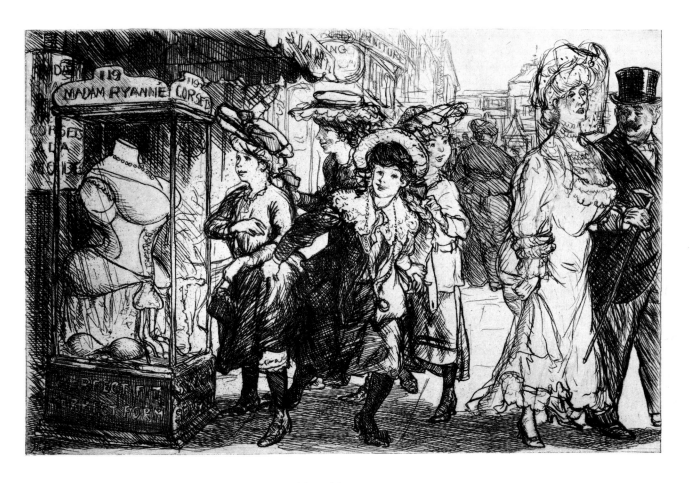

3 THE SHOW CASE 1905 4½ x 6¾ M-129

"Material from West 23rd Street and Sixth Avenue appealed to me at this time.
The devices of the toilette, which were then secrets, created more excitement among
the adolescents than they would today. Already it is apparent that the 'Connoisseurs'
motive was fading."

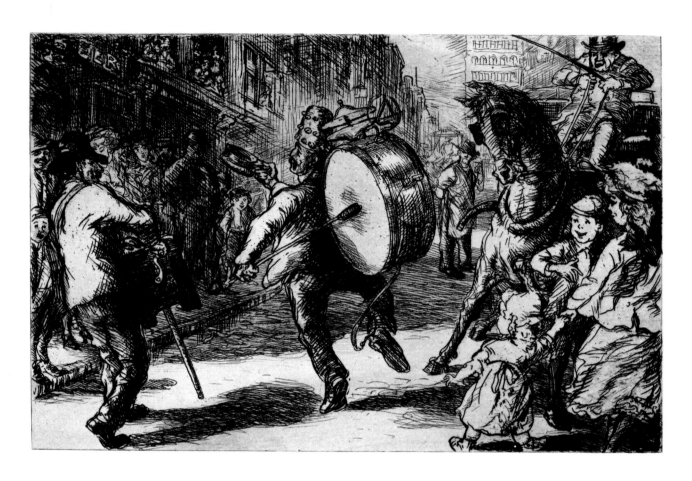

4 MAN MONKEY 1905 4½ x 6¾ M-130

"In the side streets of the Chelsea and Greenwich Village districts, the one-man band with hand-organ accompanist furnished free entertainment to those who dropped no pennies. He worried the horse-drawn traffic of the time, but before many years the automobile and motor truck cleared him from the streets."

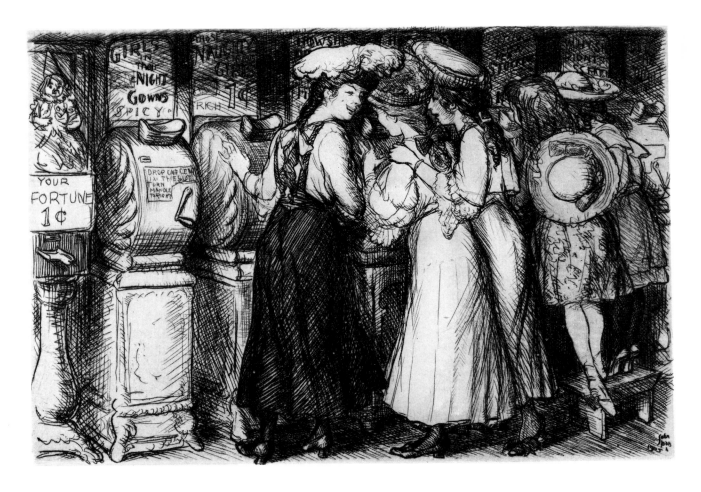

5 FUN, ONE CENT 1905 4¾ x 6¾ M-131

 "The Nickelodeon [penny arcade], with its hand-cranked moving photographs,
was one of the attractions preceding the moving-picture theatres. The one in which
I garnered this bouquet of laughing girls was for many years on Fourteenth Street
near Third Avenue."

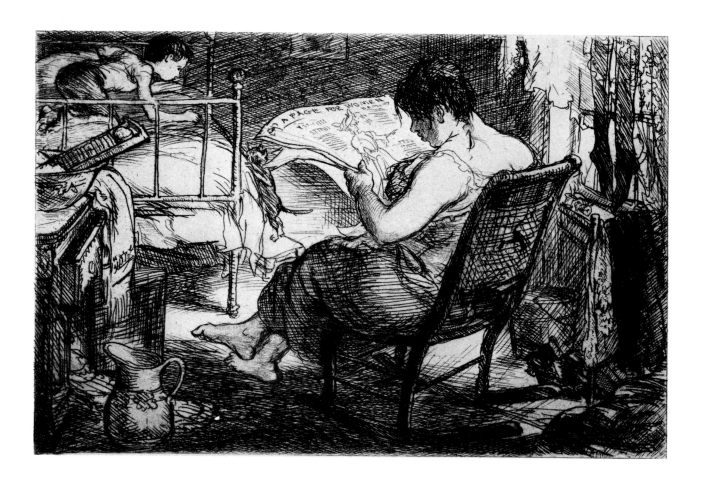

6　THE WOMEN'S PAGE　1905　4½ x 6½　M-132

"Observation of life in furnished rooms back of my 23rd Street studio inspired many of my etchings and paintings of this period. Done with sympathy but no 'social consciousness.'"

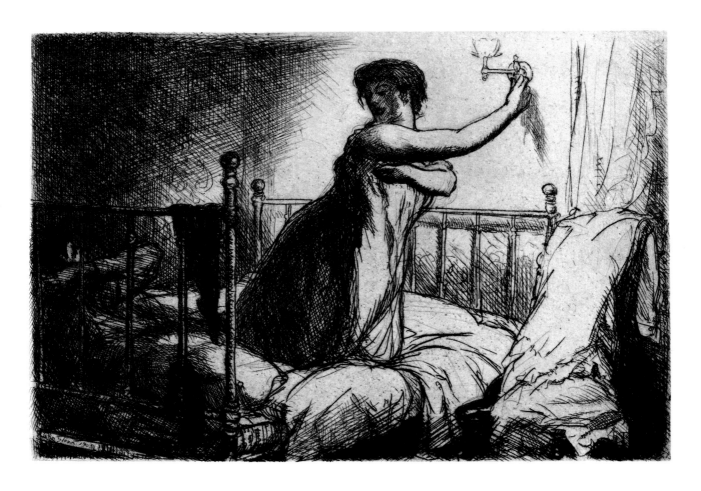

7 TURNING OUT THE LIGHT 1905 5 x 7 M-134

"This plate has 'charm': a verdict handed down by a very well-known art critic of those days, Russell Sturgis, to whom I showed this group of my New York etchings. Perhaps it has; I'm not interested. . . . I presented him with the set of ten. He kept this print and returned the rest, breaking up a set. I was really furious at the time because I was trying the sell the group of ten city-life prints—for twenty-five dollars (signed impressions)—and with very little success. Two of Henri's students bought sets at a special price of about $18.50."

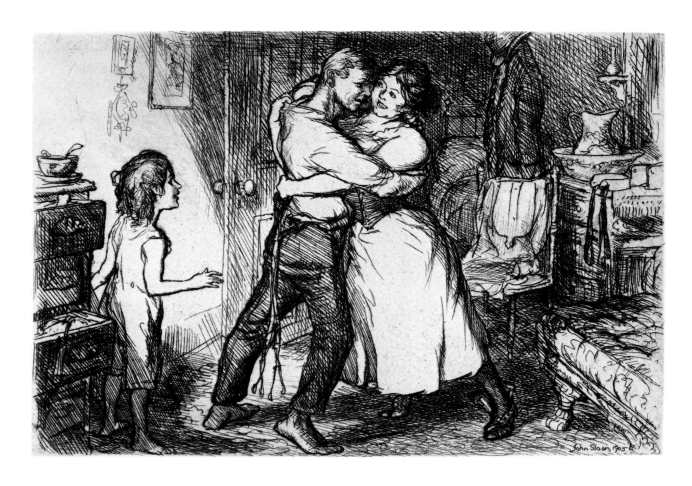

8 MAN, WIFE, AND CHILD 1905 4½ x 6½ M-135

"The conjugal status given by this title always has, I hope, prevented any improper interpretations being placed on this scene, which rewarded hours spent at my back windows. A small family in scant quarters."

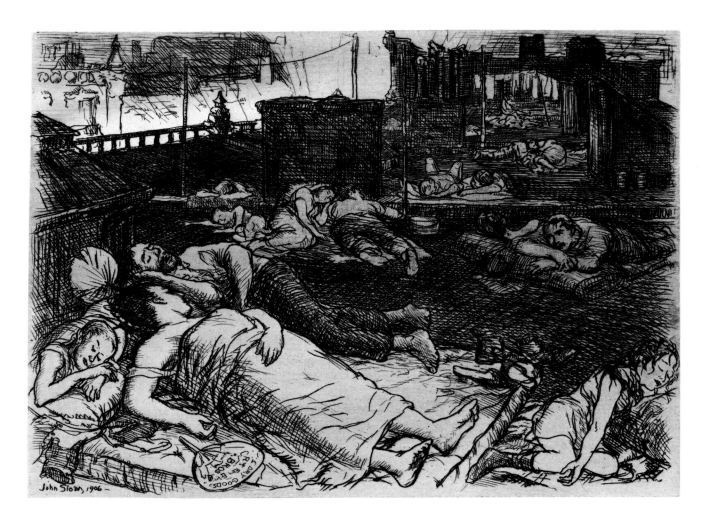

9 ROOFS, SUMMER NIGHT 1906 5¼ x 7 M-137

"I have always liked to watch the people in the summer, especially the way they
live on the roofs. For many years I have not seen the summer life of the city, which
has perhaps been better for my health than my production of city-life etchings. . . .
The city seems more human in the summer."

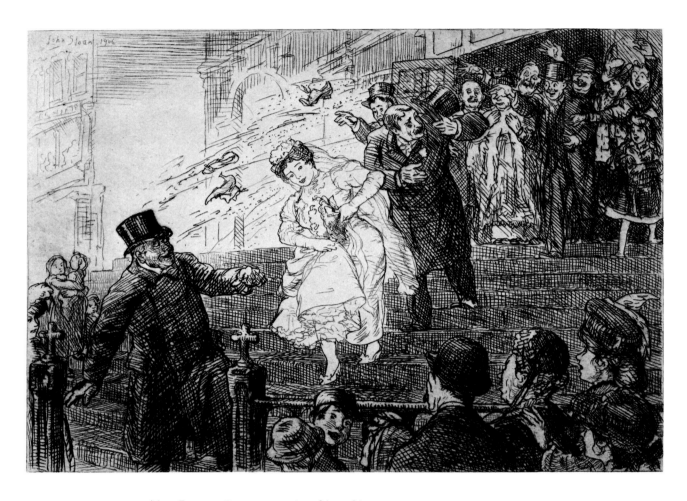

10 THE LITTLE BRIDE 1906 4¾ x 6¾ M-138

"Back in 1906 there was a considerable French population north of 23rd Street, and the church near Proctor's Theatre was known as the French Church [St. Vincent de Paul]. The stone steps down which these newlyweds are escaping have since been removed. I hope the couple lived happy ever after!"

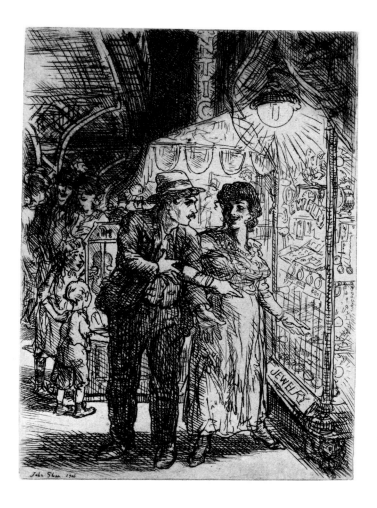

11 JEWELRY STORE WINDOW 1906 5 x 3½ M-140

"This plate was made for *Canzoni* by T. A. Daly, whose sentimentally humorous Dago dialect poems were nationally known." From Sloan's diary, Sept. 12, 1906: "Dolly and I went down to the Lower East Side about 10 o'clock this evening and saw some of the interesting life at night. I wanted to see material for the Daly frontispiece, which I made a pencil sketch for on our return at 12 o'clock."

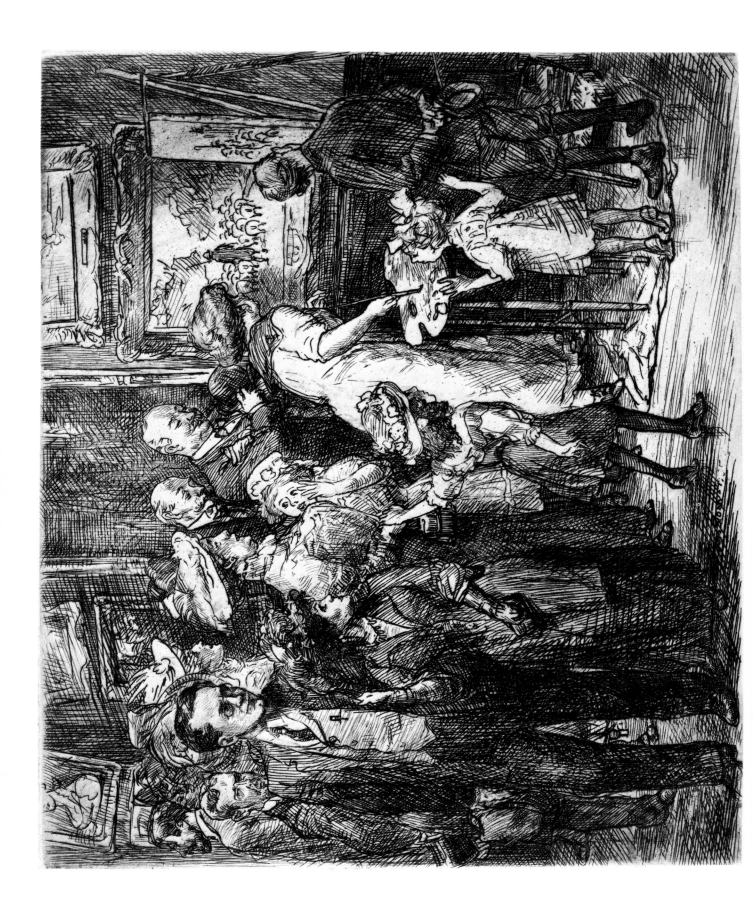

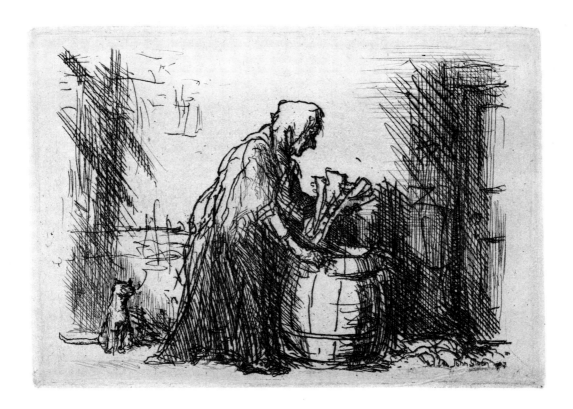

13 TREASURE TROVE 1907 4 x 5½ M-141

"This was a demonstration plate made to show the technical routine of biting various kinds of linework. Sometimes admired for its rather romantic treatment, but for the same reason not much to my liking."

12 COPYIST AT THE METROPOLITAN MUSEUM 1908 7½ x 9 M-148

"I remember having trouble with an attempt at likenesses of myself and Dolly. I've always had trouble with portraits of members of the family. I had the head of Dolly in and out of the plate innumerable times. Why should the artist be so critical in such an unimportant matter?" From Sloan's diary, Sept. 1 and 6, 1908: "Walked up to the Metropolitan Museum of Art. . . . In the evening I started to make a plate of a copyist at work . . . crowd around as it is a sheep picture which the lay copyist is 'takin' off.' Made preliminary drawing on tissue paper and grounded my plate and got the red chalk tracing sketches on the ground."

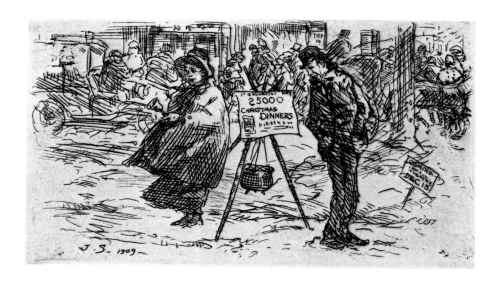

14 CHRISTMAS DINNERS 1909 2¾ x 4¾ M-149

"While contributions drop into the pot the city derelict wonders if he will live to dine. A sketch plate." From Sloan's diary, Dec. 15, 1909: "I made a small etching 'Salvation Girl' . . . announcement of 'Christmas Dinner for 25,000' and a lank hungry man loitering and wishing the Christmas dinner wasn't so far away from him. Made the plate, proved about 26 proofs and sent one to Dolly. We are going to send these around as Xmas Greetings to some of our friends."

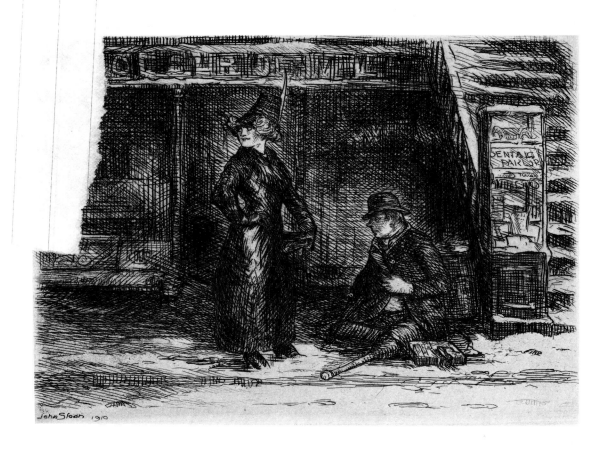

15 GIRL AND BEGGAR 1910 4 x 6 M-150

"Twenty-third Street, a winter night, and two haunters of the sidewalk. 'Putting the Best Foot Forward,' a drawing made for *Harper's Weekly*, was a variant on this theme." [Exhibited in the Armory Show, 1913. This etching and Nos. 16 and 17 were later additions to the *New York City Life* set.]

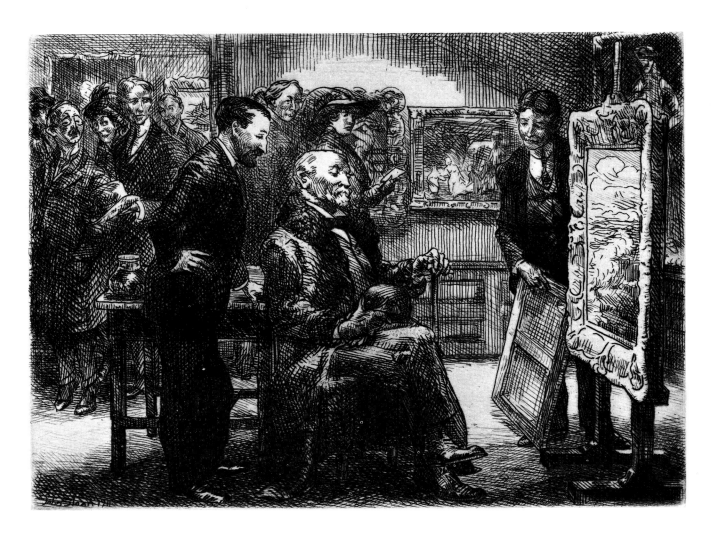

16　THE PICTURE BUYER　1911　5¼ x 7　M-153

"William Macbeth hopes to make a sale. Casual visitors . . . tiptoe about, awed by the presence of purchasing power. A strong plate." Sloan inscribed on the proof purchased by John Quinn in 1911: "An incident in the galleries of William Macbeth —he is shown purring in the ear of the victim." [Exhibited in the Armory Show, 1913.]

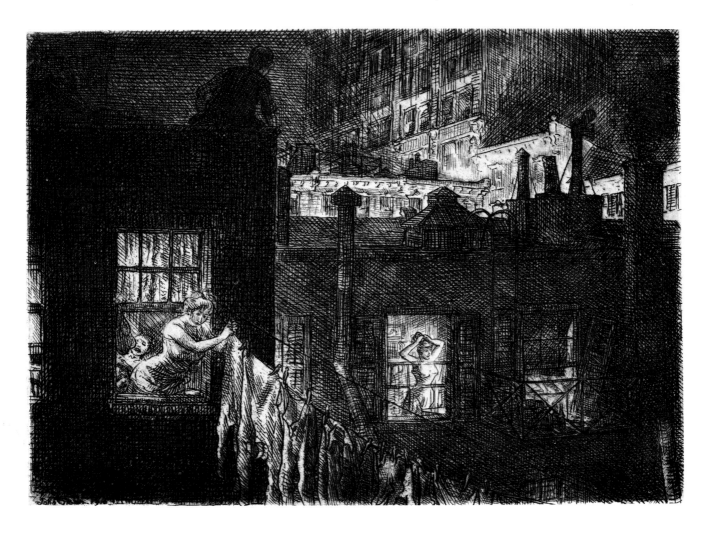

17 NIGHT WINDOWS 1910 5¼ x 7 M-152

"Perhaps I should make paintings from some of these old plates, but without the color impulse from the place itself I don't feel that I could get the livingness of the place." From Sloan's diary, Dec. 12, 1910: "I started a new etched plate after dinner. . . . The subject . . . is one which I have had in mind—night, the roofs back of us— a girl in deshabille at a window and a man on the roof smoking his pipe and taking in the charms while at a window below him his wife is busy hanging out his washed linen." [Exhibited in the Armory Show, 1913.]

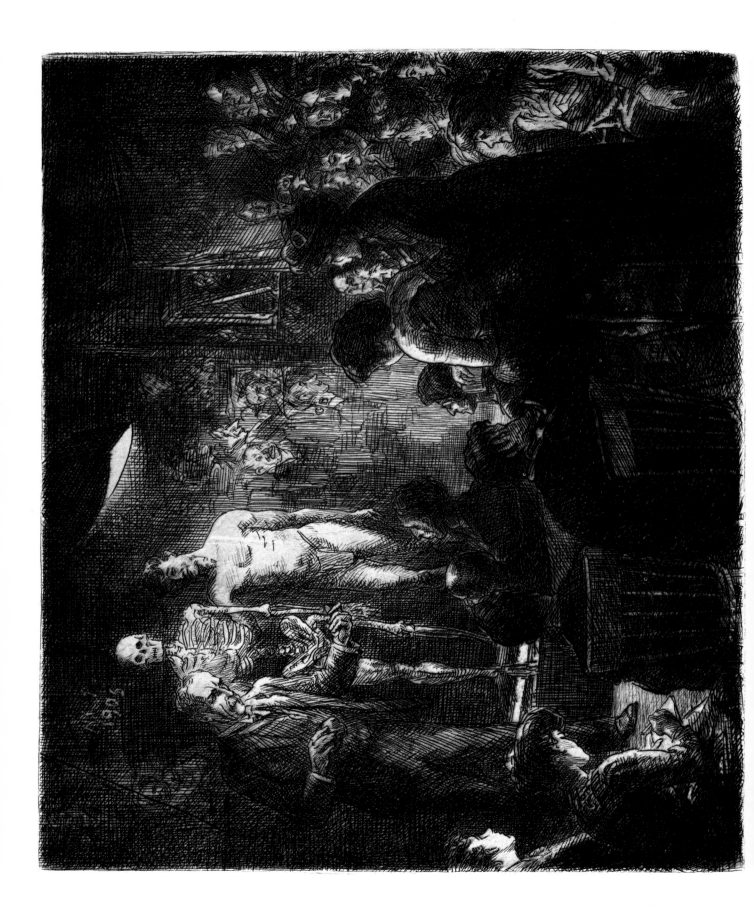

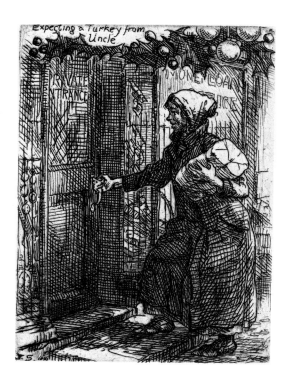

19 TURKEY FROM UNCLE 1910 3¾ x 2¾ M-151

"Two years have passed with few etchings. I remember an intensified interest in painting. During this period I first painted with Hardesty Maratta's colors, the use of which gave me my first real insight into color principles." ["Uncle" was slang for pawnbroker; thus, the woman is pawning a household item to get money for a holiday dinner.]

8 ANSHUTZ ON ANATOMY 1912 7½ x 9 M-155

"Tom Anshutz, our old teacher at the Pennsylvania Academy, gave anatomical demonstrations of great value to art students. Modelling the muscles in clay, he would then fix them in place on the skeleton. Those present in this etched record of a talk in Henri's New York class include: Robert and Linda Henri, George Bellows, Walter Pach, Rockwell Kent, John and Dolly Sloan." From Sloan's diary, Feb. 26, 1912: "I worked on plate—Tom Anshutz delivering his clay muscle talk on anatomy at the New York School of Art, about seven years ago." Mar. 4, 1912: "Worked on plate, great trouble I'm having with it—but I've got a right good portrait (memory) of Tommy Anshutz so I'll stick at the job." Mar. 6, 1912: "Scraping, polishing, hammering up, printing—struggling with the plate." June 17, 1912: "A letter from Nan Sloan announces the death of Thomas P. Anshutz, the leader of all of us—Henri, Glackens, Shinn and all the rest—Schofield, Redfield. About thirty years of service, splendid manly service as instructor in the Pennsylvania Academy of Fine Arts. We have heard recently that his highest wages was twenty-five dollars a week. This is less than an organized bricklayer gets." [Exhibited in the Armory Show, 1913.]

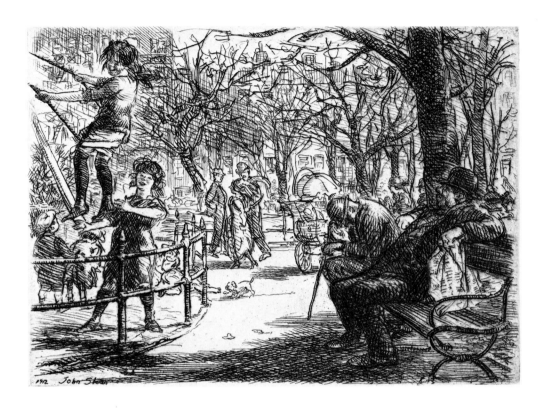

20 SWINGING IN THE SQUARE 1912 4 x 5¼ M-156

"Stuyvesant Square . . . I have always had enthusiastic interest in unspoiled girl-hood, more in evidence in 1912 than now. Growth toward real womanhood is often checked at about this age. . . . The peak of the swing, like the cover for *The Masses*, with deeper meaning."

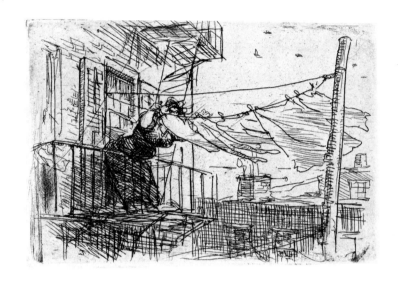

21　HANGING CLOTHES　1912　2¾ x 3¾　M-160

"One of several small plates that were sent to friends at New Year's."

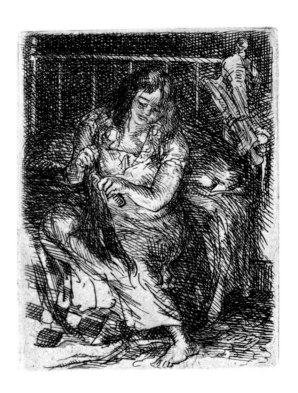

22 COMBING HER HAIR 1913 3¾ x 2¾ M-161

"The secrets of the toilette as revealed to an incorrigible window watcher. Might also have been called 'At the Switch.'"

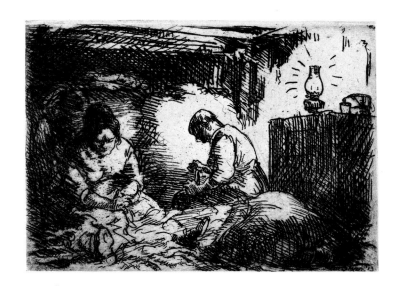

23 RAG PICKERS 1913 2¾ x 3¾ M-166

"A glimpse into one of the cellars in West Third Street under the elevated tracks, which were occupied by rag sorters."

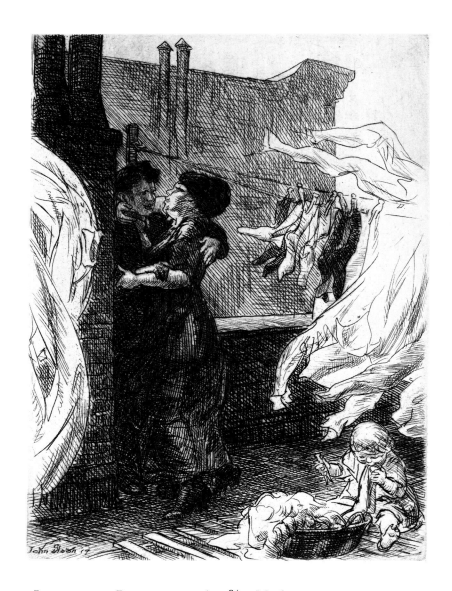

24 LOVE ON THE ROOF 1914 6 x 4⅜ M-167

"Poetic license probably permitted me to introduce many details in these city-life plates. Note the protest of the fluttering garments and the neglected child. This woman was about thirty and the boy about eighteen. The nightshirts and underwear belonged to her husband. Seen from Fourth Street and Sixth Avenue, eleventh-floor studio. All these comments are deductions. I just saw it and etched it."

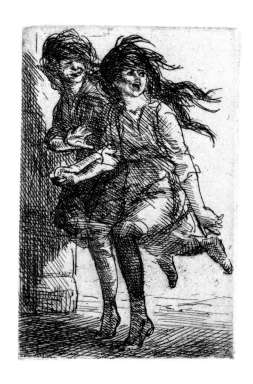

25 GIRLS RUNNING 1914 3¾ x 2⅜ M-168

"This plate is another arising from my love for untamed womanhood. Made from reality because made from memory, like all of my city-life etchings."

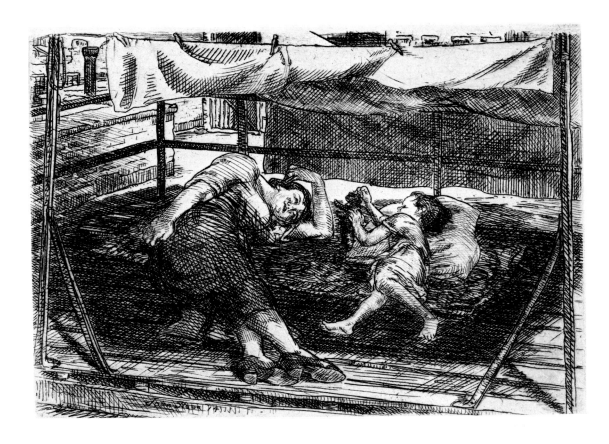

26 WOMAN AND CHILD ON THE ROOF 1914 4⅜ x 6 M-169

"The heat of summer in New York drives the folks at home to the roofs of the tenements, where extemporized shelters make spots that are comparatively cool. I suppose there are evidences of 'social consciousness' in this plate, but I hope no sentimentality. . . . This picture is an example of the kind of work I continued to make after the outbreak of World War I. Unlike Bellows and some other artists, I did not react to that war with illustrations that have a kind of romantic realism. Steinlen's etchings of the war were weakened by propaganda intent. . . . I made one strong cartoon for *The Masses* out of indignation against the destructive violence— 'A Medal and Maybe a Job.' . . . I was a pacifist during that war as I had been at the time of the Spanish-American War, when I felt that our world was entering a century of international conflicts. . . . One reason why I had hope of the socialist movement from 1910 to 1914 was that I hoped it would be a 'brake' against nationalistic competition. But I was disillusioned when the European socialists lined up for nationalism. . . . The Second World War was an entirely different matter. Totalitarianism is an example of the danger, the evil in man's desire for power over his fellowmen. A greater evil than greed for money."

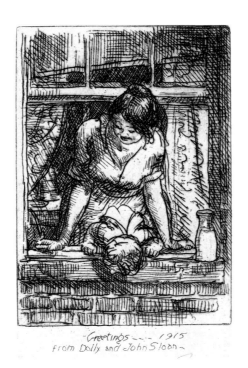

27 GREETINGS 1915 1914 $3\frac{3}{4}$ x $2\frac{3}{8}$ M-170

"One of my New Year's plates. I watched this little mother as she watched the world go by."

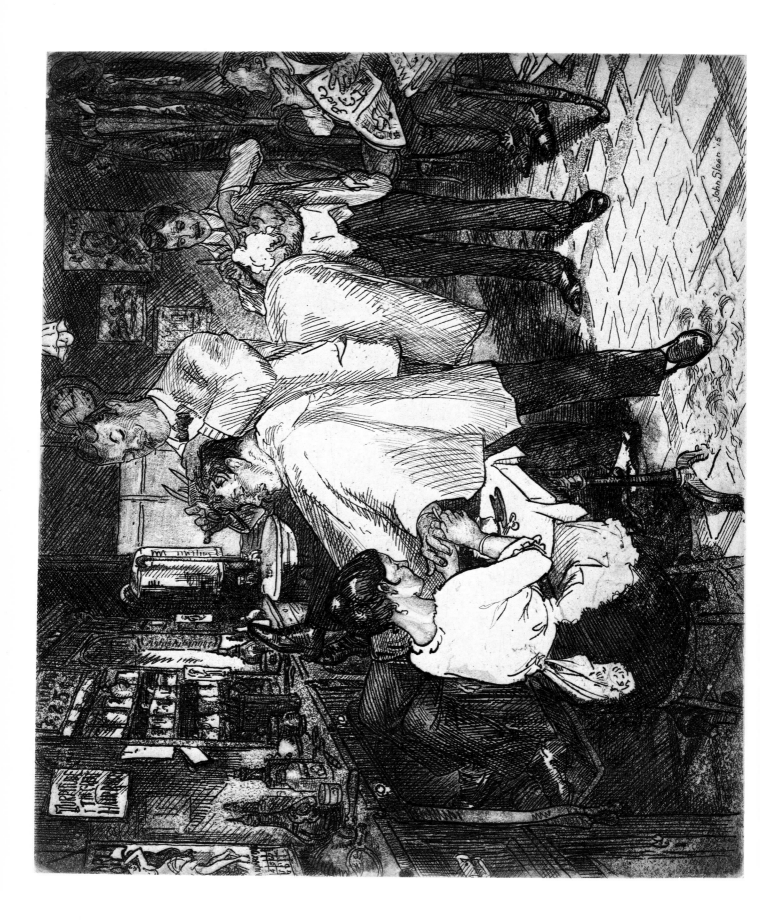

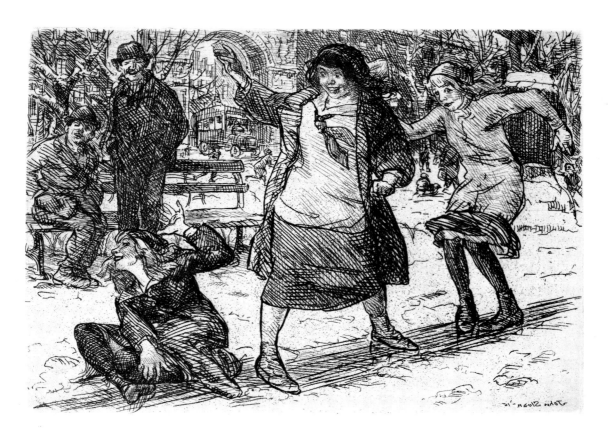

29 GIRLS SLIDING 1915 4¼ x 6 M-171

 "Healthy happy girls putting on a floor show for appreciative bums in Washington Square."

28 BARBER SHOP 1915 10 x 12 M-173

 "Done on a zinc plate, which is not susceptible to delicate biting. The linework was etched first, then the plate coated with powdered resin and prepared for aquatint in the usual manner. The lightest areas were blocked out first with stopping-out varnish, then the medium darks, while the darkest darks were exposed the longest to the acid bath. I don't remember making any previous experiments with aquatint."

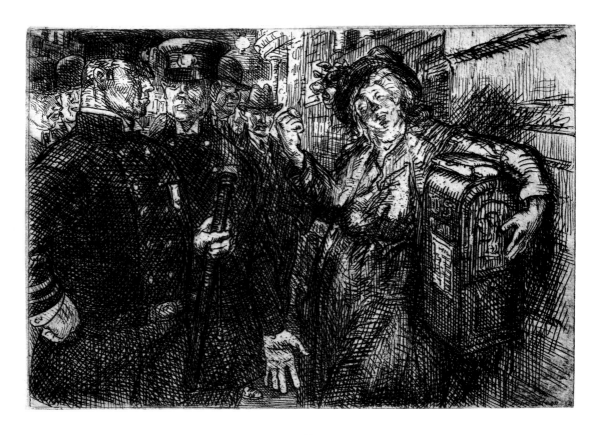

30 MARS AND BACCHANTE 1915 4¼ x 6 M-174

"A happy old harridan of pre-Prohibition days constituted herself a problem by seeking support from the U.S. Mail Box."

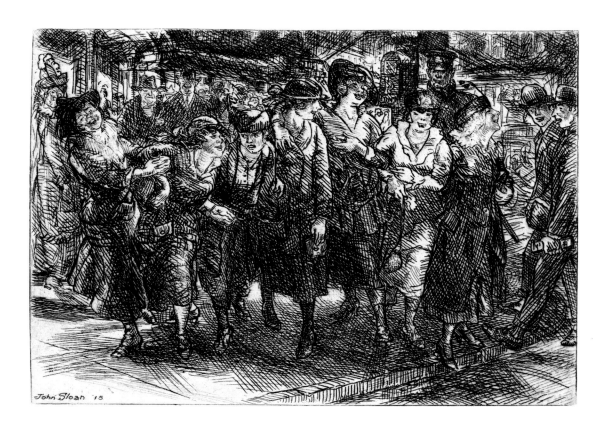

31 RETURN FROM TOIL 1915 4¼ x 6 M-175

"A bevy of boisterous girls with plenty of energy left after a hard day's work. A simplified version of this subject was made for a cover of *The Masses*."

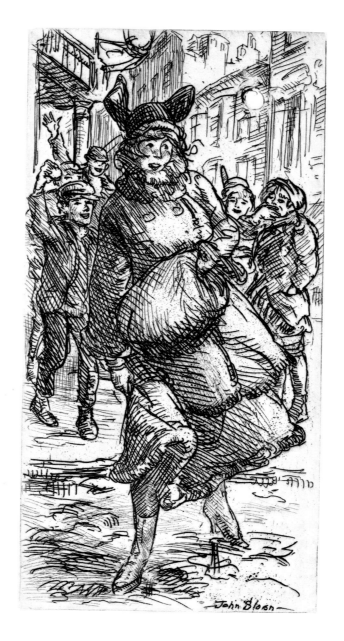

32 GROWING UP IN GREENWICH VILLAGE 1916
 6½ x 3¼ M-180

"A glimpse of the trials of a Village girl emerging into
young ladyhood."

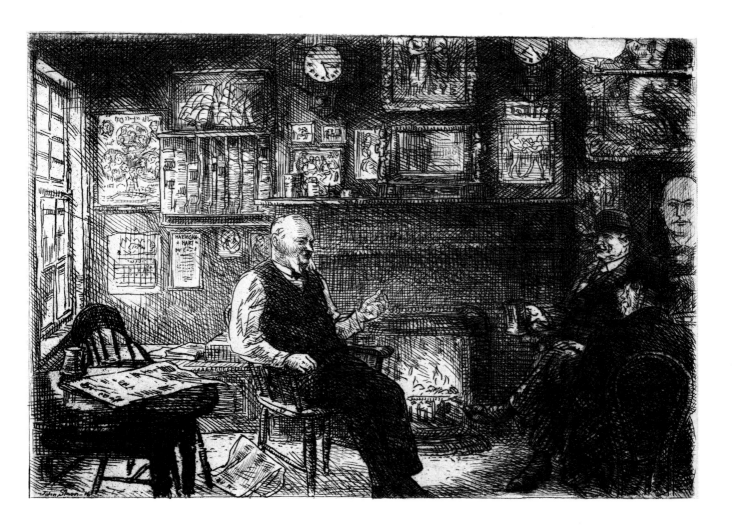

33 MCSORLEY'S BACK ROOM 1916 5¼ x 7 M-181

"Old John McSorley and two friends in the back room of the now famous McSorley's Old House at Home. Nothing but ale was ever served there. . . . A very remarkable saloon. Went right along all through Prohibition without any interference. They made their own beer in the basement. No woman ever touched foot in there and no hard liquor was ever served." "I have never gone slumming to get subject matter. I was in McSorley's ale house about ten times in my life and painted five pictures of the place." [Women's Lib changed the old masculine stronghold into a tourist attraction, but it still operates like a transplanted English pub.]

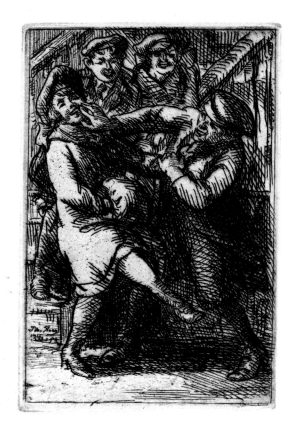

34　CALF LOVE　1916　4¼ x 2¾　M-182

　"Adolescent affection expresses itself in slaps and kicks and general rough handling."

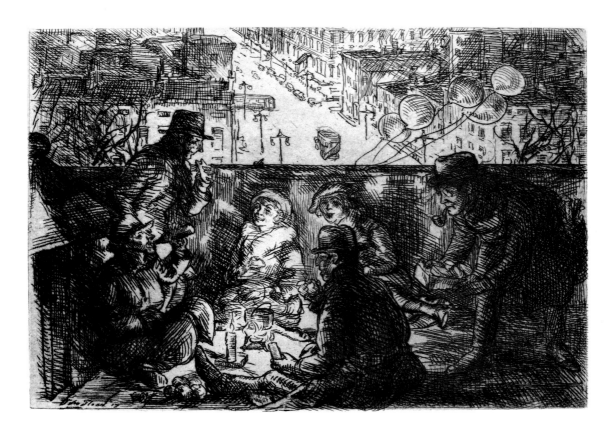

35 ARCH CONSPIRATORS 1917 4½ x 6 M-183

"A mid-winter party on the roof of the Washington Square Arch. Among those
present: Marcel Duchamp (*Nude Descending the Stairs*), Charles Ellis (actor),
John Sloan, and Gertrude Drick ('Woe'), instigator of the affair. A document was
drawn up to establish the secession of Greenwich Village from the United States
and claiming protection of President Wilson as one of the small nations. The door
of the Arch stairway has since been kept locked. . . . We had hot water bottles to
sit on, sandwiches, and thermos bottles of coffee. (Or was it tea?) . . . One of my
bohemian incidents, one of the very few." [Ellis created leading roles in plays by
O'Neill, particularly that of Eben in *Desire Under the Elms*. Gertrude Drick was a
student of Sloan.]

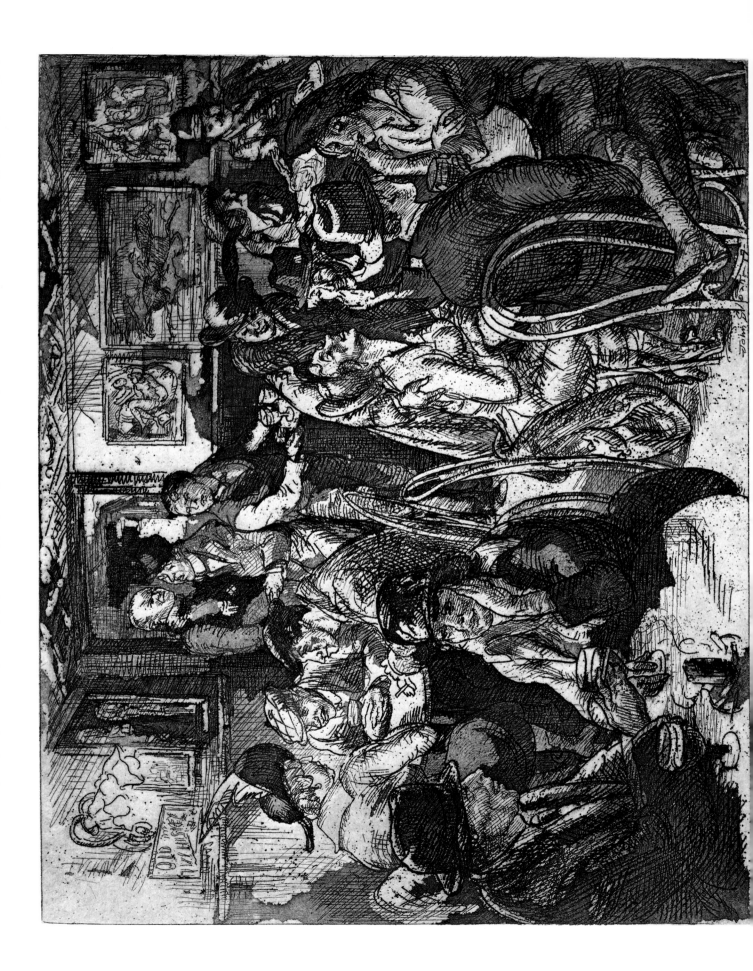

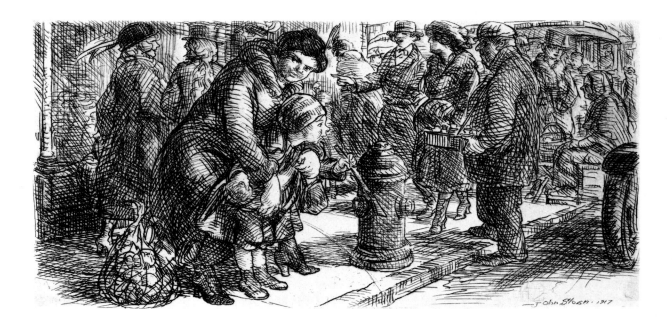

37 SIDEWALK 1917 3¼ x 6½ M-184

 "These horizontal plates I just had and used. They bring an awful pressure—no room for the 'place.' . . . An everyday incident on New York's East Side. A plate missing from most American collections."

36 HELL HOLE 1917 8 x 10 M-186

 "The back room of Wallace's at Sixth Avenue and West Fourth Street was a gathering place for artists, writers, and bohemians of Greenwich Village. The character in the upper right-hand corner of the plate is Eugene O'Neill. Strongly etched lines are reinforced by aquatint tones." [Awarded a Gold Medal at the Sesqui-Centennial Exposition, Philadelphia, 1926.]

38 SEEING NEW YORK 1917 2⅜ x 3¾ M-188

"Poultry on the way to East Side execution. A sketch
plate." From Sloan's diary, Jan. 11, 1909: "An amusing thing
—wagons loaded with coops with live poultry, on top a
lot of geese with their necks poked through the slats cack-
ling and gazing at the city—'Seeing New York' wagon."

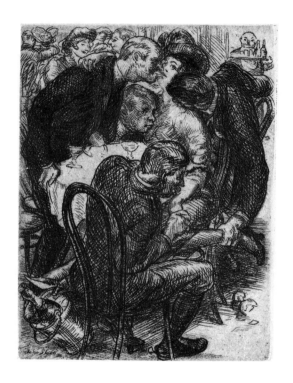

39 NEW YEAR'S EVE AND ADAM 1918 3¾ x 2¾
M-190

"With some exaggeration this records an incident of the
holiday season in a New York hotel, the Brevoort."

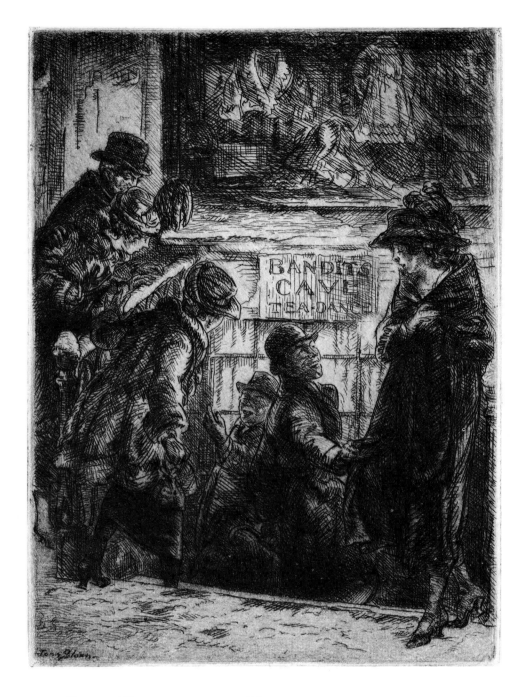

40 BANDITS' CAVE 1920 7 x 5 M-195

"Uptown thrill seekers during the period of Prohibition are about to venture
into a basement 'tea room' in Bohemia. . . . One of the cafés in the Village."

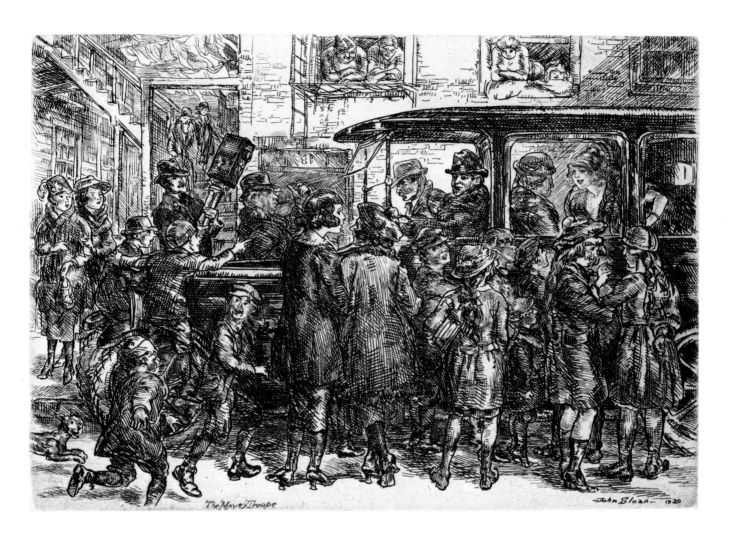

41　THE "MOVEY" TROUPE　1920　5¼ x 7　M-196

"One of the early movie troupes on location. Director, leading man, leading lady, and camera man have made use of one of the picturesque backgrounds to be found in Greenwich Village at that time."

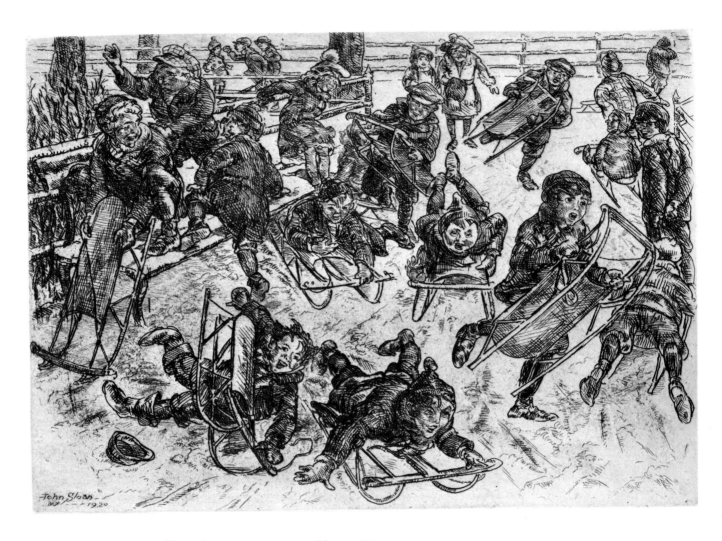

42 BOYS SLEDDING 1920 5¼ x 7 M-197

"A lively impression from Washington Square after a snowstorm. In going back over my etchings for the purpose of these comments, it seems notable that I have been more interested in life than in 'art.' Too many of us today are over-concerned with formulas. There is little doubt, however, that we will emerge eventually better artists for having been through a period of conscious study."

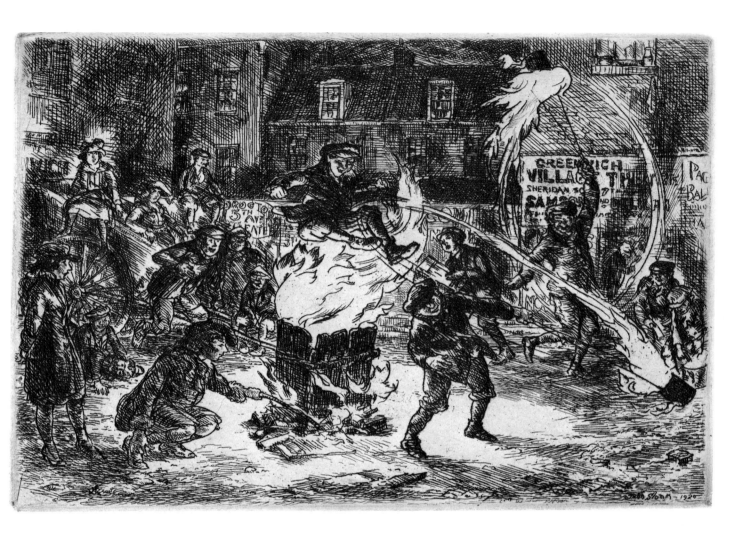

43 BONFIRE 1920 5¼ x 7½ M-198

"This fire frolic in a vacant lot has resulted in a plate with fine qualities of light and movement. . . . The boys had tin cans with wire handles, filled with embers."

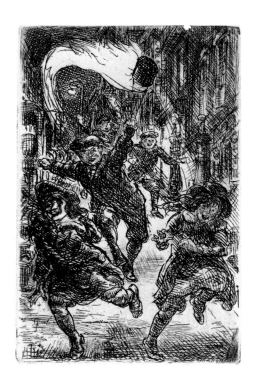

44 FIRE CAN 1920 3¾ x 2⅜ M-199

 "A New Year plate dealing with the 'fun with fire'
theme."

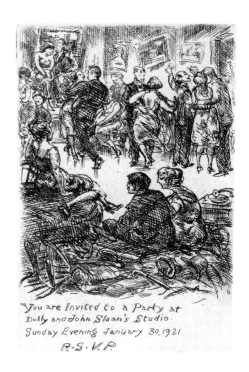

You are Invited to a Party at
Dolly and John Sloan's Studio.
Sunday Evening January 30, 1921
R·S·V·P·

45 INVITATION TO STUDIO PARTY 1921 3¾ x 2⅜
 M-200

"This little plate, in which the technique is so well
adapted to the scale, foretells a gay party at the studio."

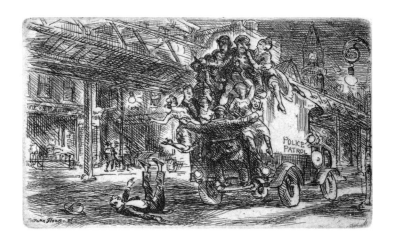

46 PATROL PARTY 1921 2⅜ x 3¾ M-202

"Another invitation for a studio party during Prohibition. Here again the technique is well adapted to the size of the plate."

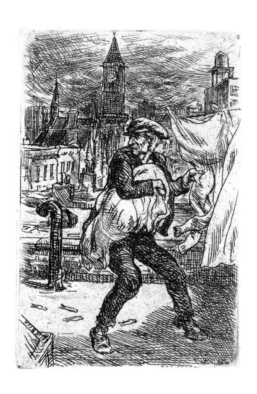

47 STEALING THE WASH 1921 3¾ x 2⅜ M-204

"A connoisseur of woolen underwear makes his selection from a wash hung out
on the roofs below my studio window. . . . An incident I saw from my Fourth
Street studio some years earlier, on a Saturday or Sunday. I watched this fellow pick
out all the work things from the line. Then he hid behind a chimney and tried on
all the woolen socks he had stolen. He wrapped the rest in a neat bundle, cleaned
his feet, and went down the fire escape. I felt in the position of God Almighty—
saw this crime and didn't do anything, as God wouldn't. I didn't have a phone, but
that's how I figured it out. A few minutes later I saw the discovery of the theft.
A stout Italian woman saw these gashes on her line like missing teeth. Then she
started to gesticulate, went and got four other women, and told her story."

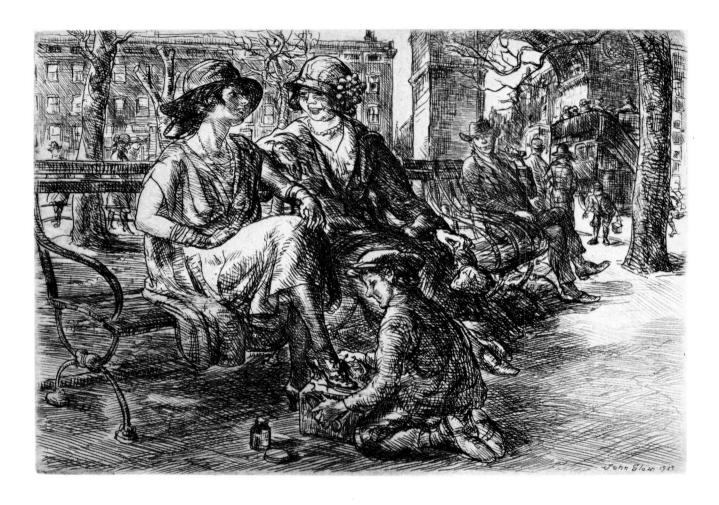

48 SHINE, WASHINGTON SQUARE 1923 5 x 7 M-206

"It has been said that my work has been influenced by Cruikshank, but no critic
has traced it to its true source, which is the work of John Leech, particularly in
his *Punch* drawings. Cruikshank's people always have a quality of caricature. . . .
This etching might convey to the mind of a psychoanalyst the idea that the etcher
would have willingly changed places with the bootblack for the nonce. Perhaps so."

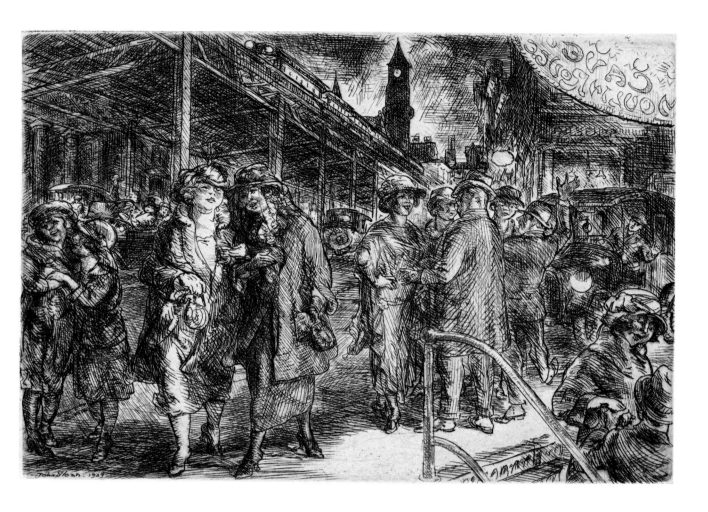

49 SIXTH AVENUE, GREENWICH VILLAGE 1923 5 x 7 M-207

"Jefferson Market Police Court tower in the background. . . . Looking at this etching with the plates of Albrecht Dürer in mind, one notes a great difference in design and technique. Here, life is stressed, and formal composition is less evident, the handling more emotional. A comparison of extremes, perhaps."

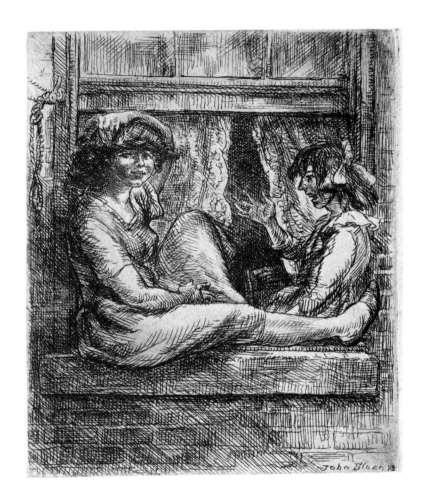

50 SISTERS AT THE WINDOW 1923 5 x 4 M-208

"One sister younger, and mean. Technically a beautiful plate. . . . A girl on the brink of adolescence under the watchful eye of her younger sister, both under the watchful eye of the neighboring etcher. Subject matter which produced one of my best plates. . . . A sketch of the subject dated 1920 shows the lapse of time, in this case, between the original idea and its formal expression."

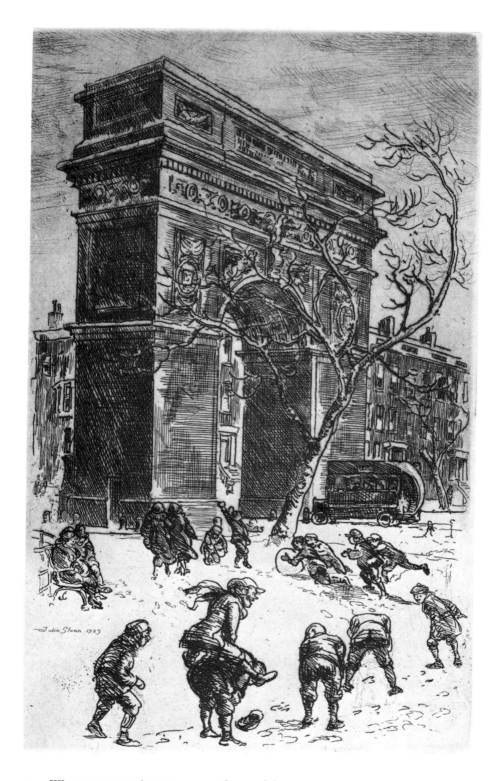

51 WASHINGTON ARCH 1923 8 x 5 M-212

"A simple and telling design which would have been weakened by more delicate technical approach. The state with lettering was made for our friends George and Elizabeth Hamlin, who had bought twenty paintings to help us with hospital bills. Both Dolly and I had been under the surgeon's knife in 1922. A publicity story about the sale was put out by our friend Holger Cahill, 'a twenty thousand dollar sale.' The Internal Revenue Service audited my tax report for that year, and found that I had truthfully recorded the real price, which was actually five thousand dollars."

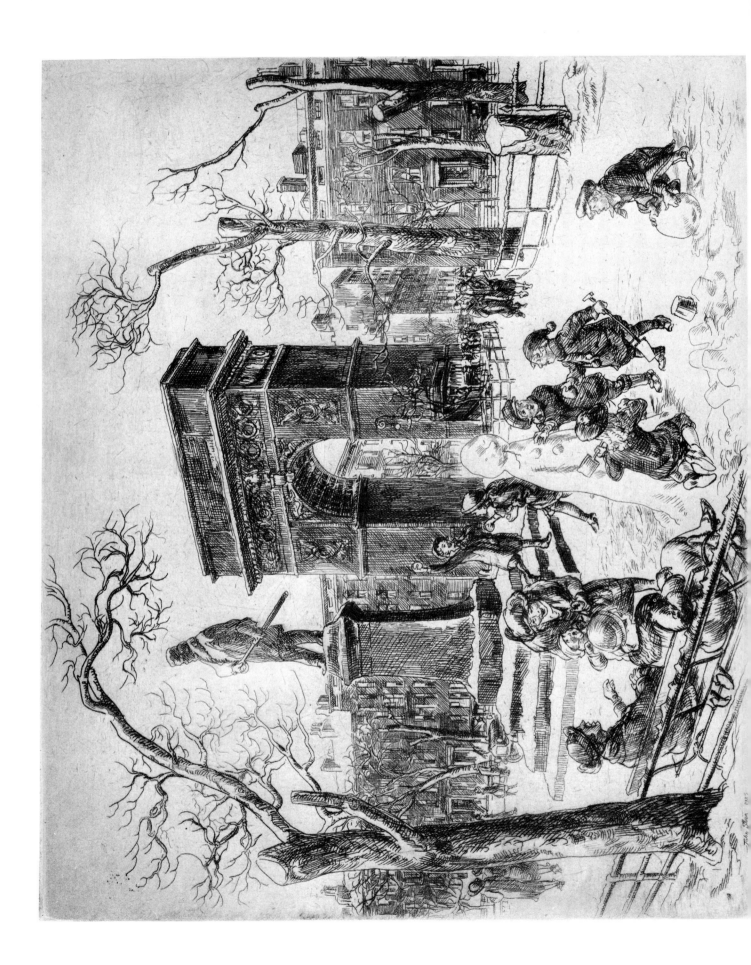

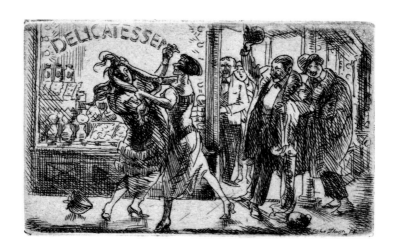

53 BOB CAT WINS 1924 2⅜ x 3¾ M-214

"A feminine row outside a 'tea room' during the days of Prohibition, demonstrating the advantages of the new bobbed hair in such an encounter. . . . Little restaurant 'coffee houses' where people sat drinking cups of tea less than half full with no milk in them. I was amused by some of these speakeasies—but never liked the kind of cheap (but expensive) entertainment in the night clubs that flourished during the Twenties."

52 SCULPTURE IN WASHINGTON SQUARE 1925 8 x 10 M-218

"The title refers to the Garibaldi statue, the Washington Arch, the snow man, and the helter skelter Tammany tree surgery. A lot of funny cripples in the way of trees. The life of Washington Square furnished me with much material. I often regret leaving the neighborhood. . . . After living at 88 Washington Place for about ten years, we moved to 53 Washington Square shortly after this plate was made. When New York University took over the old Judson Hotel in 1935, I begged the institution to permit me to stay. Offered to teach, or take classes in Latin or geometry. . . . We moved to the Hotel Chelsea on West 23rd Street, a block away from my first New York studio apartment."

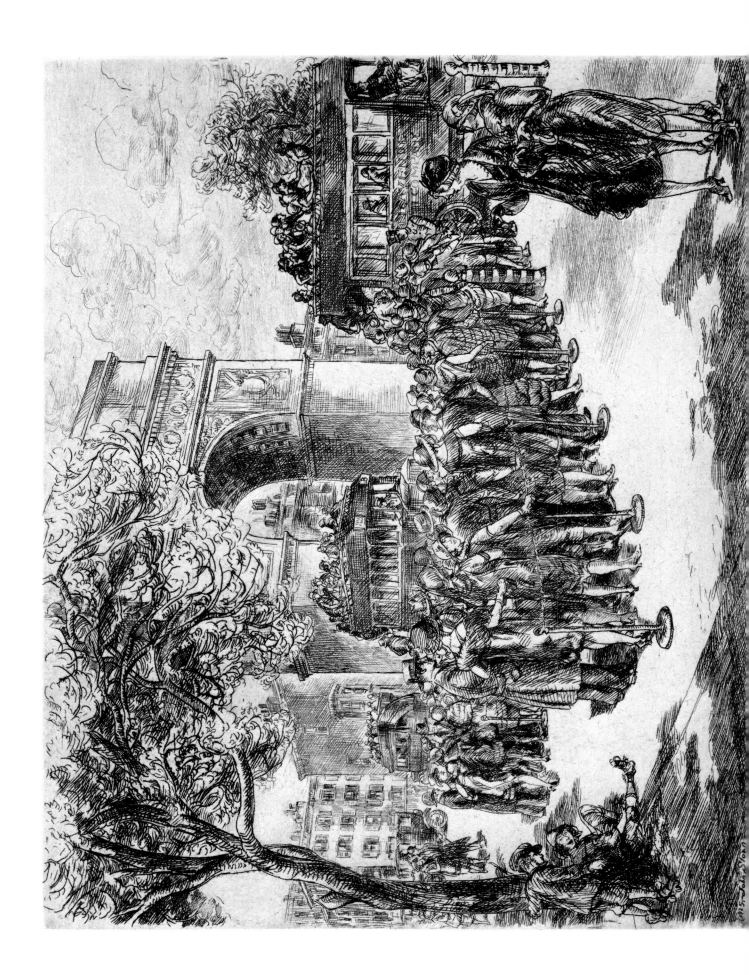

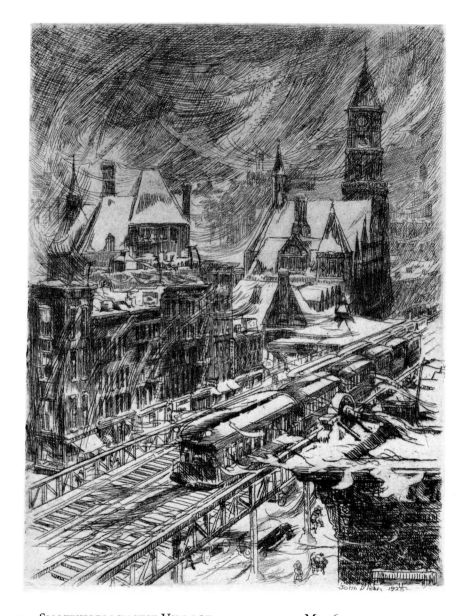

55 SNOWSTORM IN THE VILLAGE 1925 7 x 5 M-216

"Viewed from my studio on Washington Place, the Jefferson Market Court
tower and elevated tracks on Sixth Avenue under a swirl of snow. . . . Professional
printers sometimes leave too much tone on this kind of plate. In my later work, I
rely less on plate tone, retroussage—and no longer like the romantic character of
brownish printing ink."

54 BUSSES IN WASHINGTON SQUARE 1925 8 x 10
M-219

"Holiday afternoons and Sunday were busy days for the
Riverside Drive busses leaving the Square. My studio
windows overlooked this patient crowd; this etching and
several paintings of similar scenes resulted."

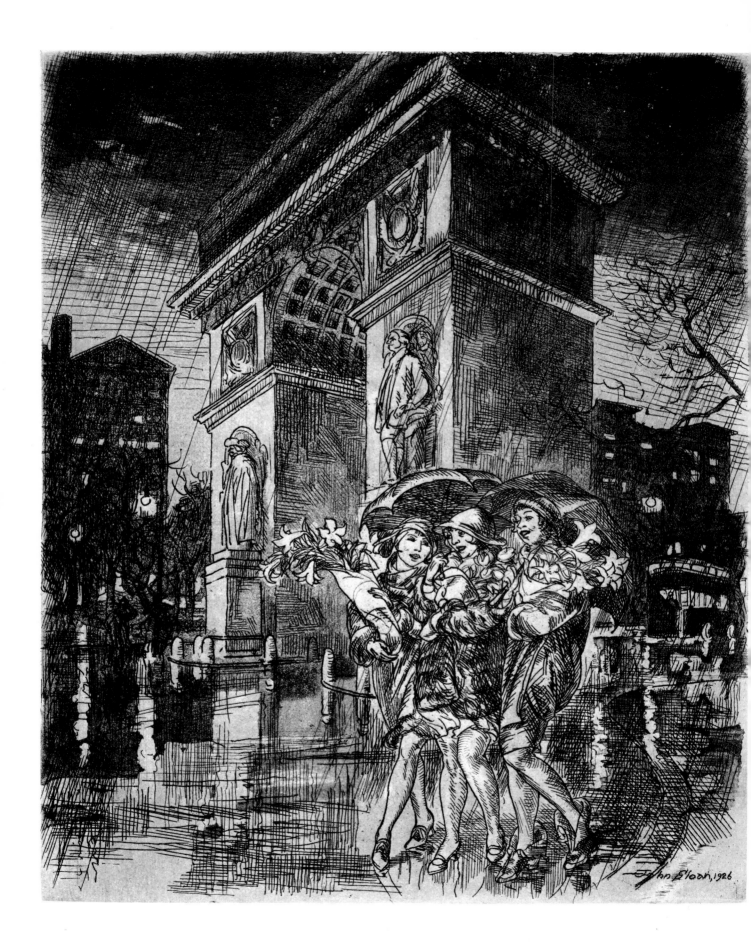

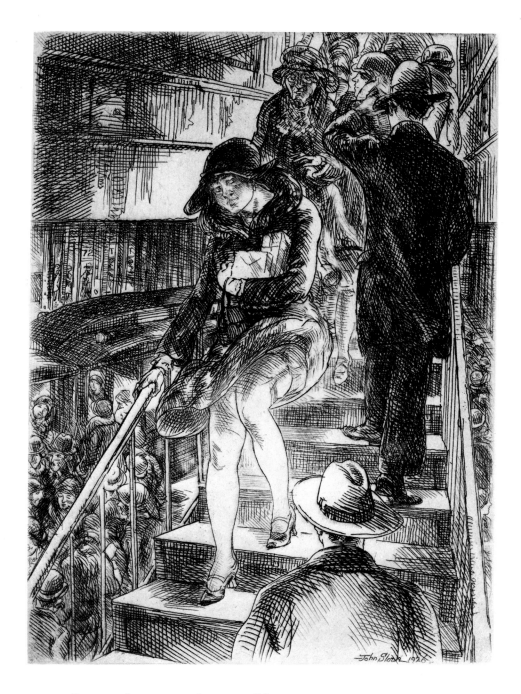

57 SUBWAY STAIRS 1926 7 x 5 M-221

"In modern times incoming trains cause updrafts in the subway entrances.
Getting on an omnibus in the hoopskirt was exciting in grandmother's day. . . . I
enjoy a jolly subject like this just as I like a healthy kind of ribaldry. There is
something clean and wholesome about ribaldry that is completely different from
the salacious or pornographic."

56 EASTER EVE, WASHINGTON SQUARE 1926 10 x 8 M-222

"An aquatint record of an April shower, happy girls and
spring flowers. . . . I hardly ever use a zinc plate. They are
so soft that you can't work on them long before they get
worn down in deep hollows. . . . The *Easter Eve* was

started as a pure etching and the lines were bitten too
deeply and coarsely, so I went on and made an aquatint of
it."

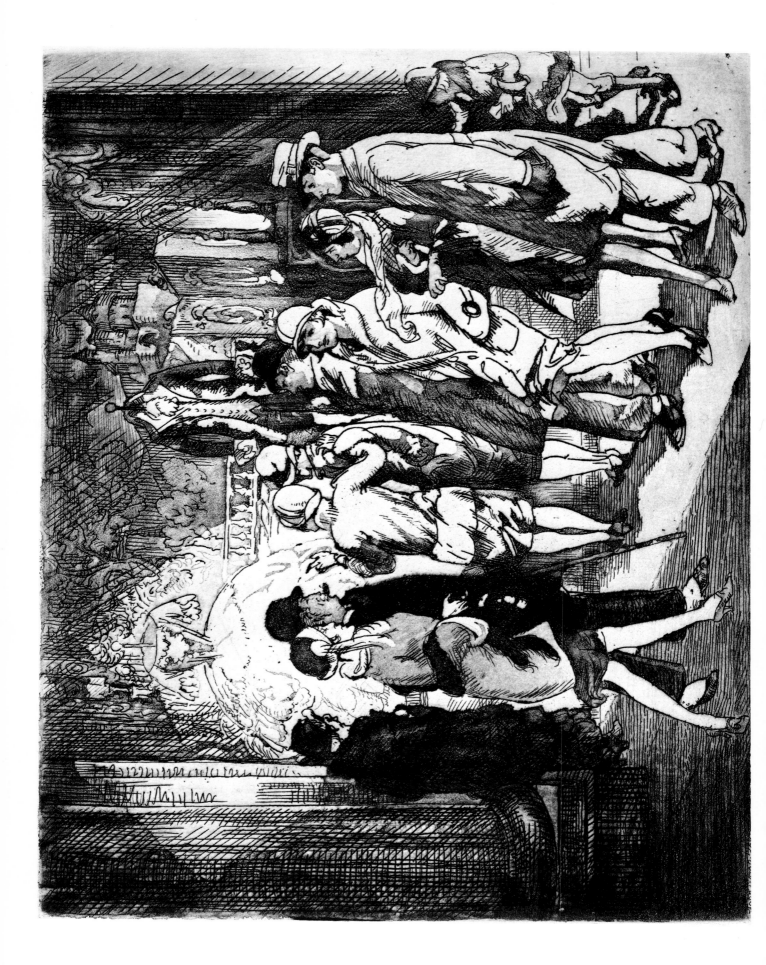

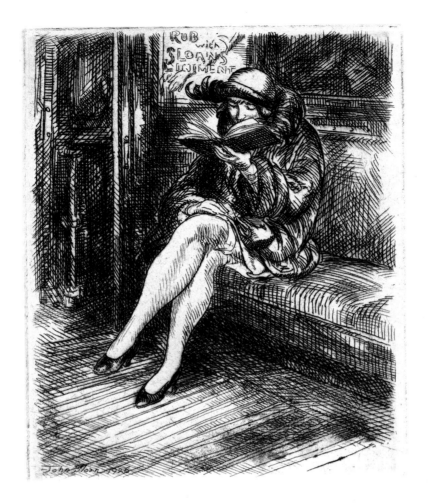

59 READING IN THE SUBWAY 1926 5 x 4 M-223

"As Sir John Suckling wrote in 1620:

> Her feet beneath her petticoat
> Like little mice peeped in and out,
> As if they feared the light.

I had these lines in mind when I saw the scene. . . . [Frank] Crowninshield re-produced it in *Vanity Fair* enlarged, which isn't good for an etching." [Note the advertisement on the rear wall.]

58 FASHIONS OF THE PAST 1926 8 x 10 M-224

"A well-arranged shop window and the contrasting cos-tumes of the passers-by, whose dress of the time will in turn become costumes of the past. . . . Lord & Taylor."

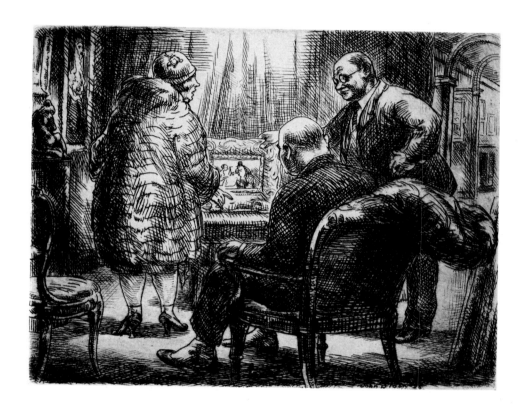

60 KRAUSHAAR'S 1926 4 x 5 M-229

"My old friend, John F. Kraushaar, engaged in the difficult job of selling a
picture to a man whose wife feels she needs sables. . . . My old friend J.F.K. engaged
in the difficult job of helping a husband persuade a lady who already has a mink
coat that she could add to her splendors by owning a painting."

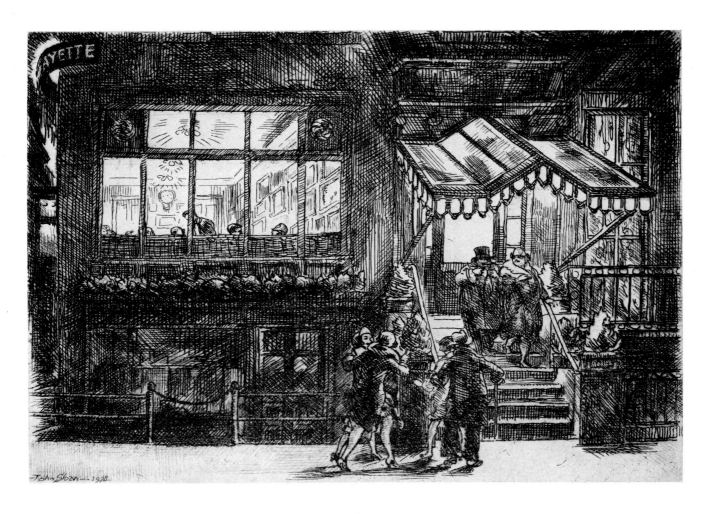

61 THE LAFAYETTE 1928 5 x 7 M-233

"An old restaurant and hotel where French cuisine has been for years and still is regarded as one of the best in New York. The atmosphere of the nineteenth century remains. . . . I painted the place, a picture which is now in the Met[ropolitan Museum]. This plate was made for subscribers who contributed to the purchase fund. I felt I had squared myself in a way by sending them this print."

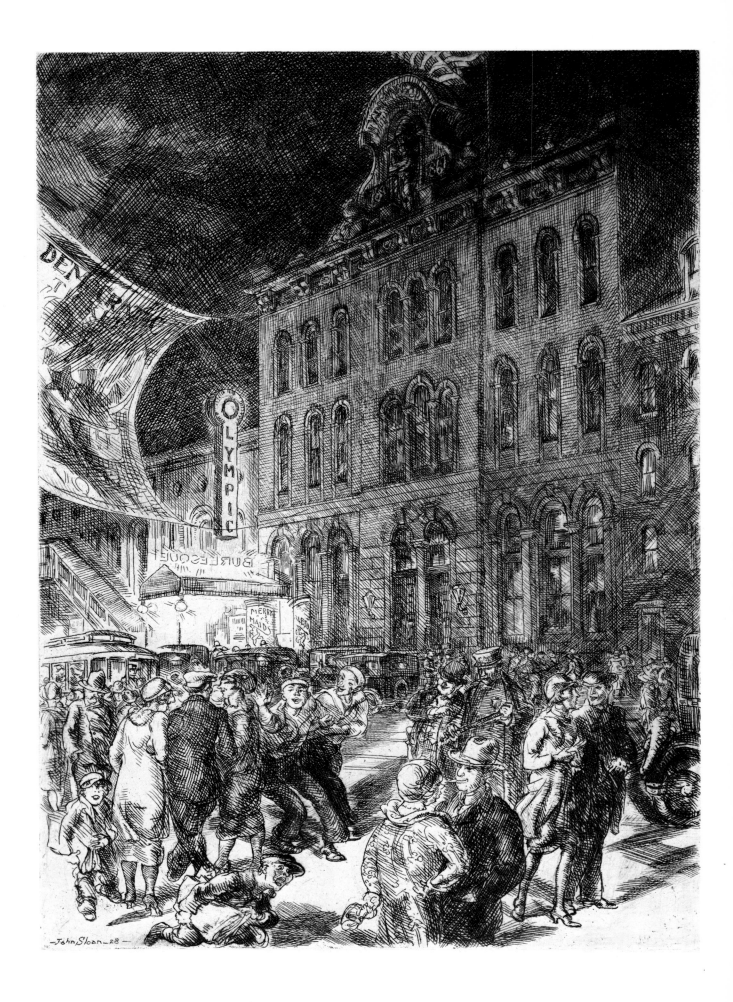

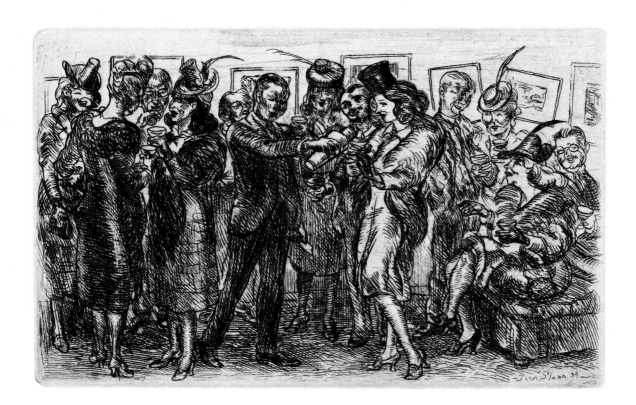

63 A THIRST FOR ART 1939 4 x 6 M-306

"One of those exhibition-opening cocktail parties. . . . They don't see the pictures at all, knocking them crooked on the wall with their shoulders."

62 FOURTEENTH STREET, THE WIGWAM 1928 9¾ x 7 M-235

"Old Tammany Hall, the headquarters of the bosses of New York City, has ceased to exist. It lurked, menacing, in dingy red brick, facing the tawdry amusements of East Fourteenth Street. . . . During the Depression I painted *Old Tammany Hall* (1934) from the etching—under the beginning of the Public Works of Art Project. When Mrs. Force was running it you didn't have to be a pauper. If you didn't have a steady income of sixty dollars a month you were eligible. In fact, I was invited along with some other older artists, to demonstrate that the selection was based on quality as well as need. A group of protesters picketed the Whitney Museum, which had provided office space for the project. I painted two pictures in the two months I was employed, and then resigned."

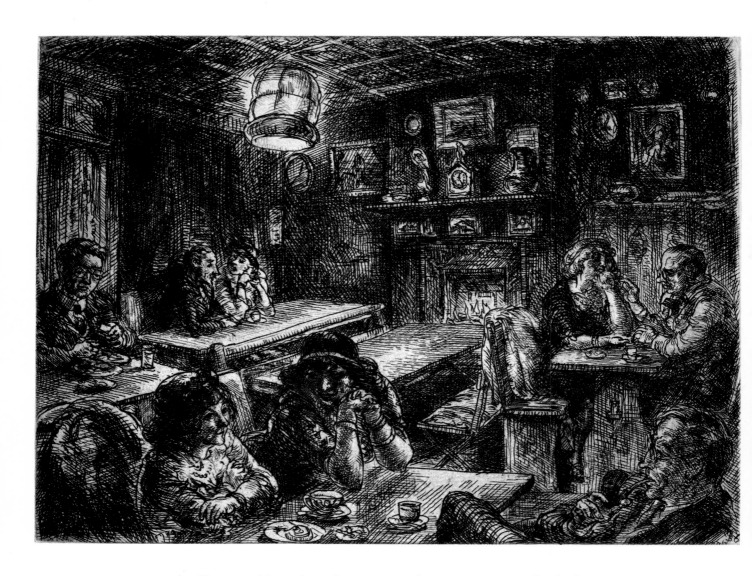

64 ROMANY MARYE'S IN CHRISTOPHER STREET—1922 1936 6 x 8
M-278

"All Greenwich Villagers know Romany Marye, who has acted the part of
hostess, philosopher, and friend in her series of quiet little restaurants for the past
thirty-five years. The etching shows her chatting in her deep comfortable voice to
Dolly and myself. . . . She only sold liquor in the last few years and then under
pressure from a partner. . . . Dolly Sloan spent a lot of time there, but I never went
in for tea-table conversations." [The hostess' name was actually spelled "Marie."]

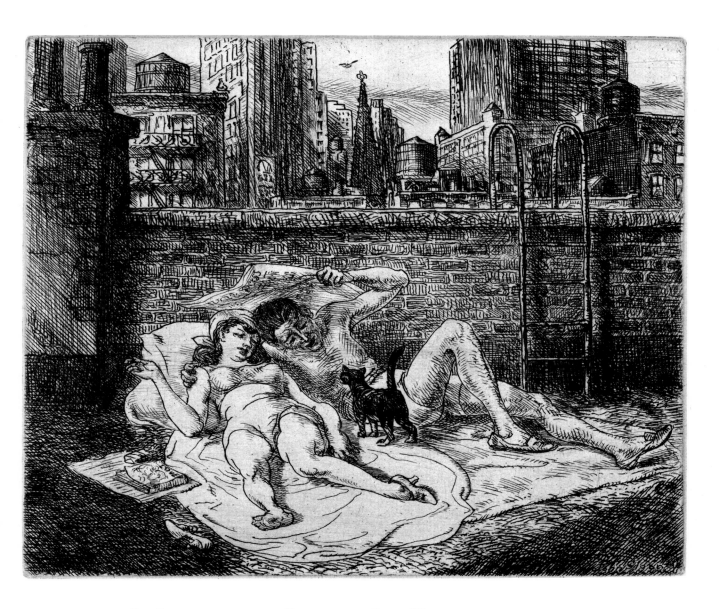

65 SUNBATHERS ON THE ROOF 1941 6 x 7 M-307

"I spent the summer in our Santa Fe home recuperating from a second operation for obstruction of the gall duct complicated by double pneumonia. For months before I started this plate my hands were crippled with rheumatism. It was commissioned by the College Society of Print Collectors. . . . Twenty years during which my summers were spent in Santa Fe lessened my opportunities of studying New York City life at its best in the summer. This etching, done many years after most of my New York plates, is, I think, of equal merit."

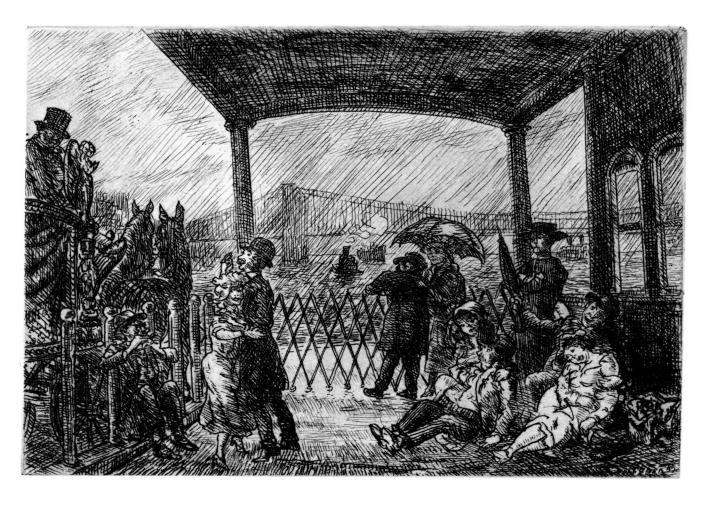

66 THE WAKE ON THE FERRY 1949 5 x 7 M-313

From Sloan's diary, Mar. 11, 1949: "I looked over some old sketches hoping to find a subject for the etching I am to make for the A[rt] S[tudents] League. Some of these sketch notes as far back as 1908–1913 make me regret that I have not done this sort of thing for years." July 15, 1949: "Letter from Cleveland in re my making an etching for their print club. Answering, they suggest that I make a lithograph of one of my old paintings, *The Wake of the Ferry*. I won't do it. But that gives me an idea for a humorous plate, 'The Wake *on* the Ferry' (drunken Irish wake). A hearse and merry-making mourners on the front of a ferry boat. . . . Parody of my 1907 picture in the Phillips Gallery."